IMAGINISTIX

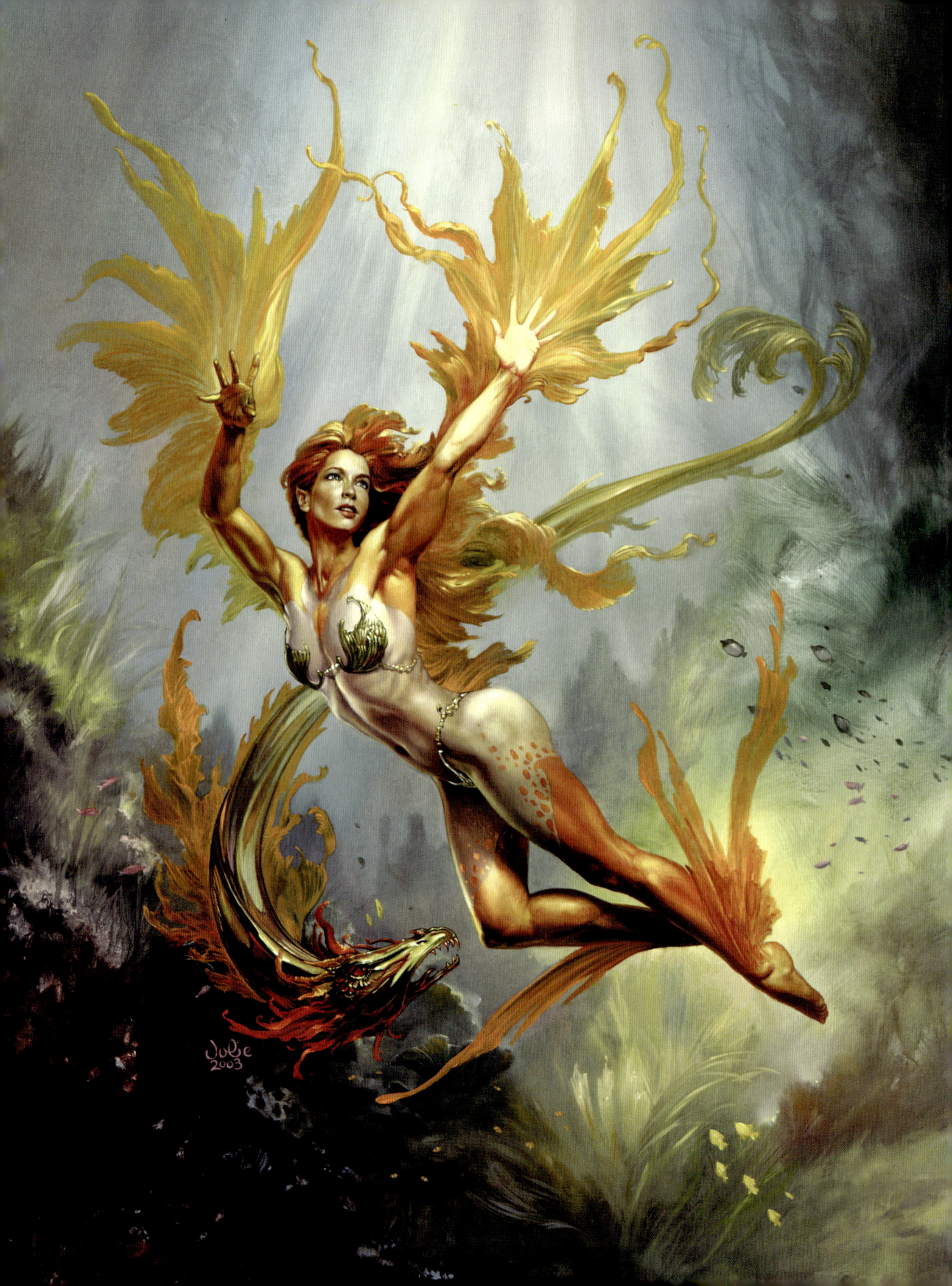

IMAGINISTIX
THE ART OF BORIS VALLEJO AND JULIE BELL

TEXT BY ANTHONY AND DAVID PALUMBO

COLLINS | DESIGN
An Imprint of HarperCollinsPublishers

CONTENTS

INTRODUCTION

Page 6

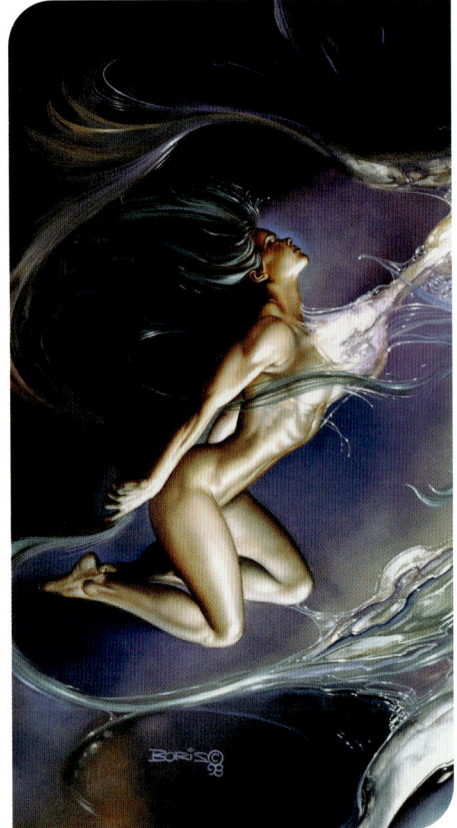

CALENDAR

Page 10

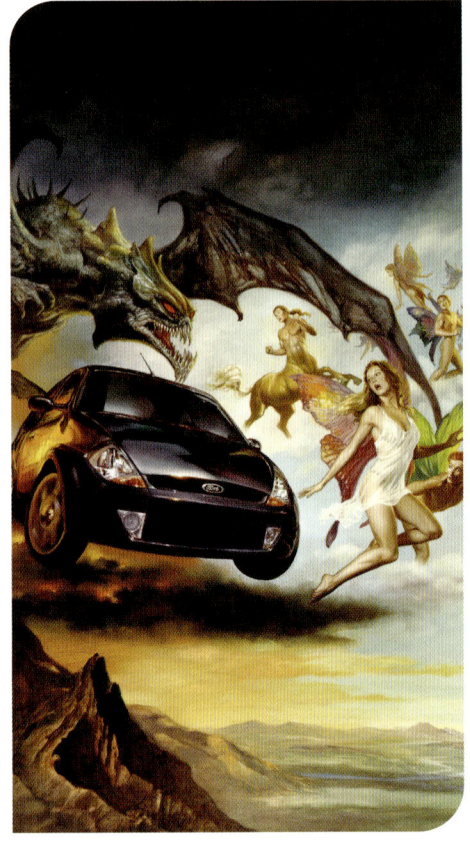

ADVERTISING

Page 68

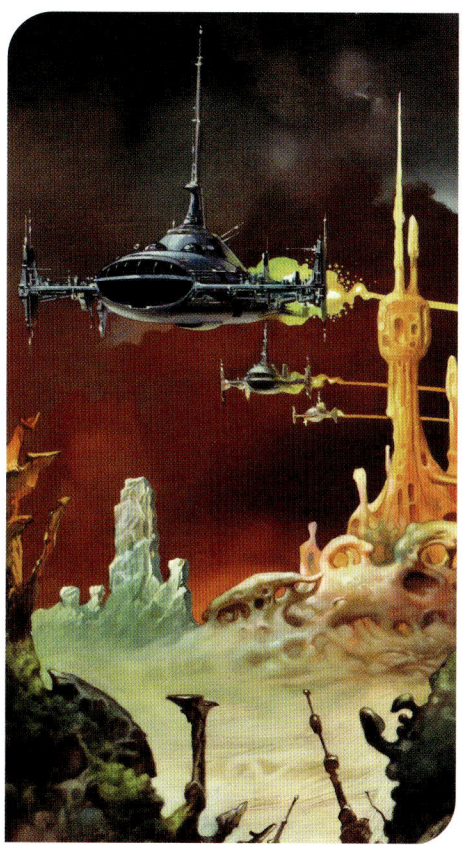

BOOKS

Page 94

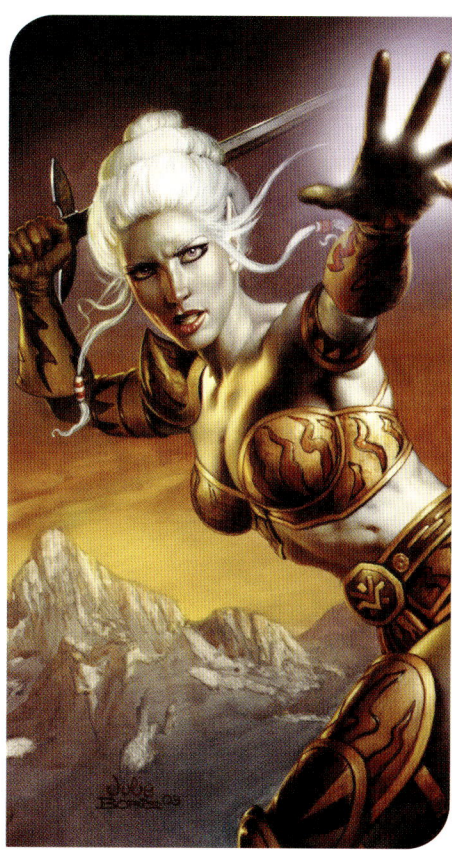

AND THEN...

Page 154

BORIS VALLEJO AND JULIE BELL: IMAGINISTIX
The Art of Boris Vallejo and Julie Bell

Text Copyright © 2007
by Anthony and David Palumbo
Illustration Copyright © 2007
by Boris Vallejo and Julie Bell
Meat Loaf © 2006 Southern Star Management.
Reprinted By Permission.
Aqua Teen Hunger Force, the logo and all related
characters and elements are trademarks of and
© 2007 The Cartoon Network.

All rights reserved. No part of this book may be
used or reproduced in any manner whatsoever
without written permission except in the case of
brief quotations embodied in critical articles and
reviews. For information, address Collins Design,
10 East 53rd Street, New York, NY 10022.

HarperCollins books may be purchased for
educational, business, or sales promotional use. For
information, please write: Special Markets
Department, HarperCollins Publishers Inc., 10 East
53rd Street, New York, NY 10022.

First published in North America in 2007 by:
Collins Design
An Imprint of HarperCollins*Publishers*
10 East 53rd Street
New York, NY 10022
Tel: (212) 207-7000
Fax: (212) 207-7654
collinsdesign@harpercollins.com
www.harpercollins.com

Distributed throughout North America by:
HarperCollins*Publishers*
10 East 53rd Street
New York, NY 10022
Fax: (212) 207-7654

Library of Congress Control Number:
2007928783

ISBN: 978-0-06-113846-1
ISBN-10: 0-06-113846-0

Printed and bound by CT Printing Ltd, China
Color Reproduction by Dot Gradations Ltd, UK
First Printing, 2007

INTRODUCTION

As an art director my main objective is to create book jackets that will stop a consumer in their tracks and make them instantly connect to a product they might know nothing about. Boris and Julie are masters at creating strong and engaging images that pull a reader in and invite them to enter into extraordinary worlds.

To say that Boris and Julie are masters of figure painting almost seems unnecessary considering their spectacular body of work, but such an accomplishment should never be taken for granted. Their abilities were not handed to them but, instead, come from decades of dedicated observation and training. I am constantly stressing the importance to aspiring young artists of exceptional figure work necessary on book covers. If the figure is off, even a little, consumers will sense it right away. Boris and Julie's intimate knowledge of anatomy and impeccable rendering enables the viewer to connect to the characters depicted in an immediate and visceral way. Even when the characters are idealized and engaged in mythic battle we relate to them as the epitome of humanity—strong, independent, graceful, and sensual.

Boris and Julie's anatomical expertise extends to their non-human characters as well—whether mythical beasts or creatures from the woods, the viewer never questions their believability within the picture. The creatures are every bit as powerful and strong-willed as any of the people depicted.

Suspension of disbelief is complete when entering into Boris and Julie's paintings—people have wings, dragons are real, wolves are sentient. All of this is accepted without question and we are allowed to step into impossible worlds unhindered by mundane concerns.

Irene Gallo, Art Director—TOR Books

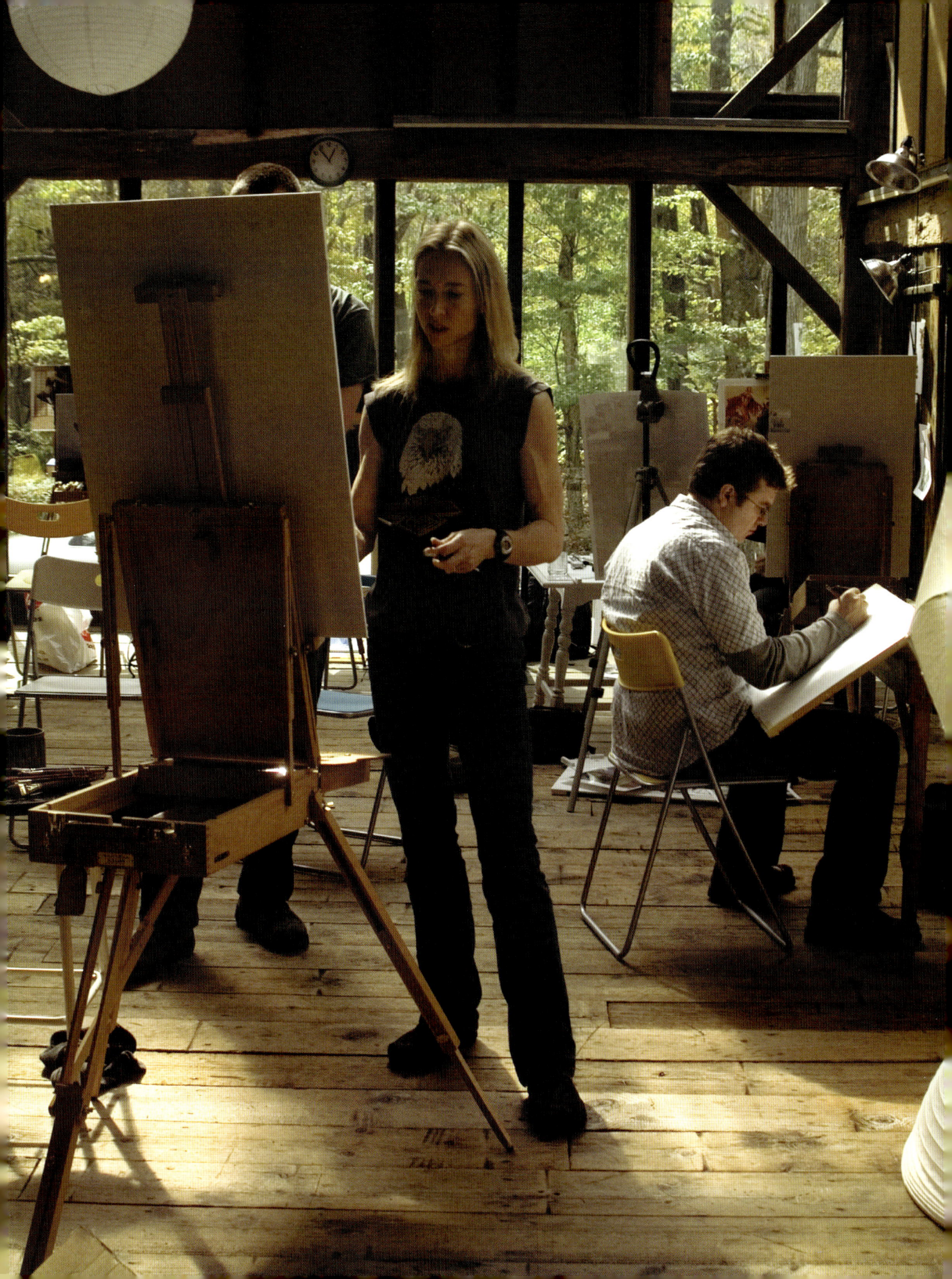

We believe that artists are born as artists. Their talents can be either nurtured and encouraged or inhibited and unrealized. Through the years of our lives, we both have been fortunate enough to cross paths with countless "art nurturers" in the form of family and friends. During our careers, fans of our work have, perhaps unknowingly, given us direction, feedback, and criticism, forging a solid link between their love of fantasy and our artistic imagination. In this age of the internet, this connection has expanded on a world-wide scale, opening our eyes, minds, and hearts infinitely further than we could have dreamed of in our childhoods.
Thank you to all of you! What an amazing world we share!

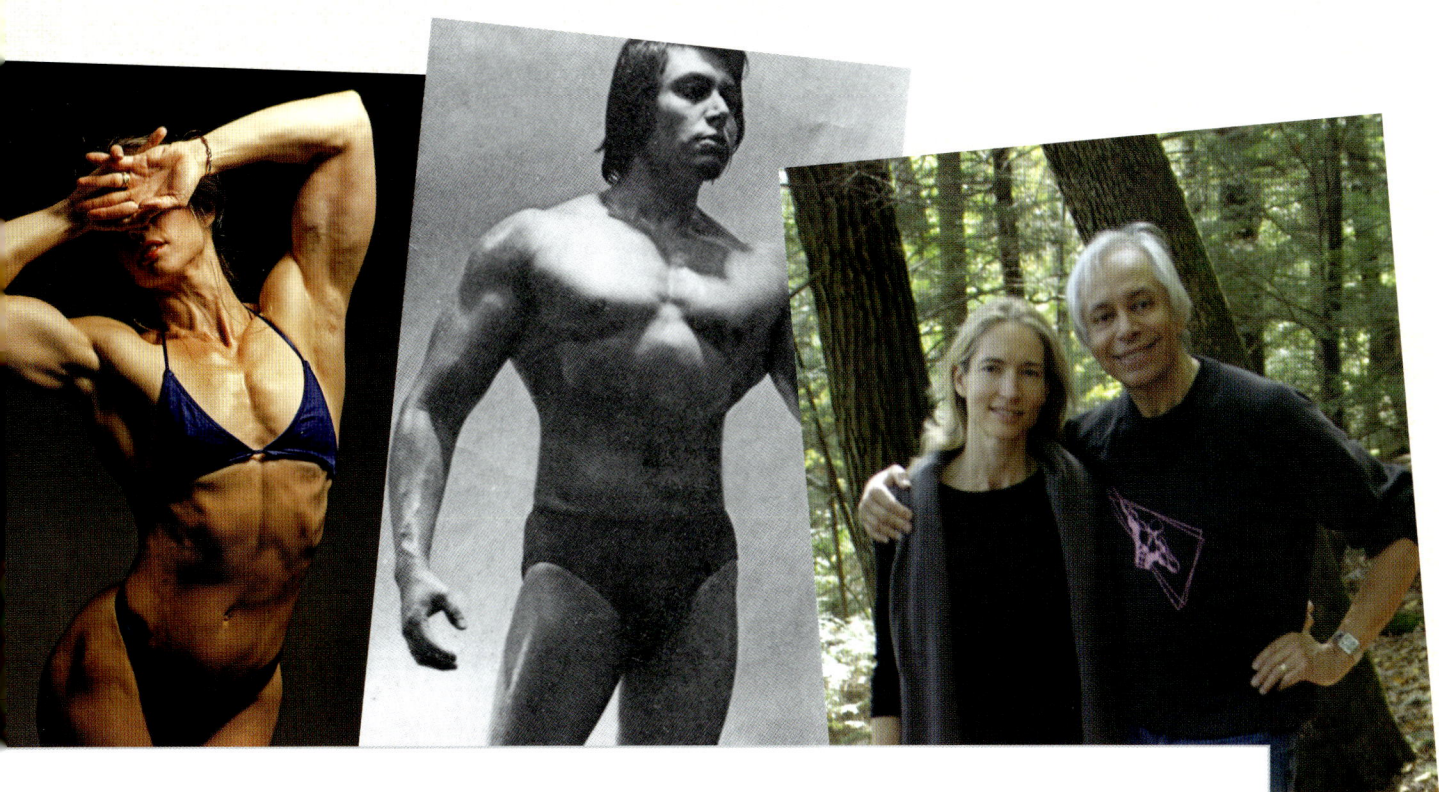

Boris & Julie

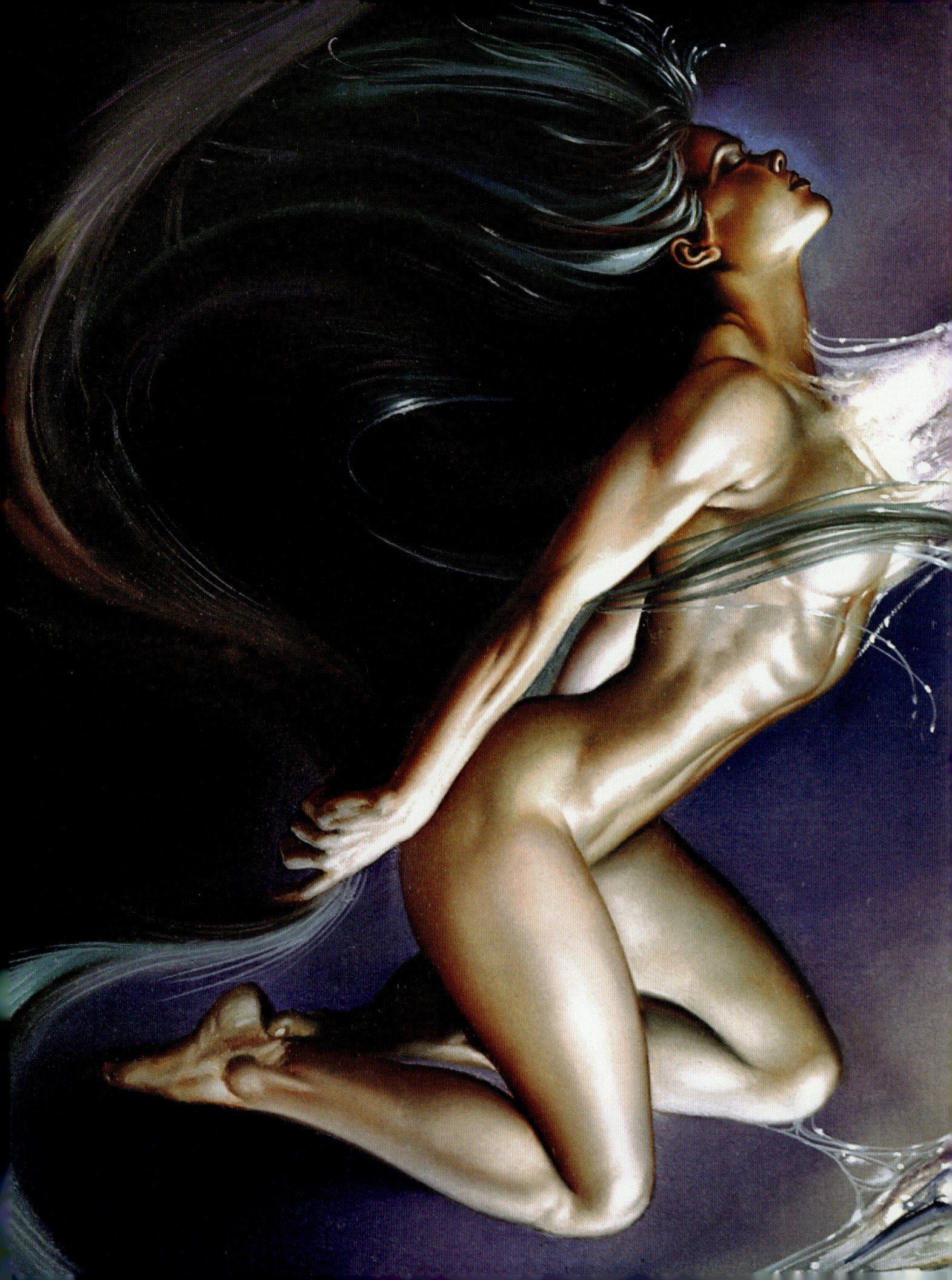

One of the most exciting elements of Boris and Julie's body of work is the ongoing series which has been produced for their annual fantasy calendar. While most illustrations are commissioned by a client for a specific product or purpose, the calendar gives Boris and Julie total freedom in their creative process. It provides them an annual forum in which they can showcase their own personal ideas, and keeps a periodic record of their artistic direction. This tradition began, in a roundabout way, with a painting of Tarzan almost three decades ago.

In 1976, Boris's first Tarzan cover hit the bookshelves. At the time, no single artist had ever painted covers for all two dozen volumes of Edgar Rice Burroughs's Tarzan series. Boris's rendition of Tarzan the Terrible pleased the publishers so much that he was asked to be the first to tackle all 24. Ultimately though, he would only complete 12. This may have only been half of the series, but it also happened to be the perfect number of images for a calendar, and so Boris's first calendar was released by Ballantine in 1978 comprising all of his Tarzan pieces.

Exciting as it was, the Tarzan calendar was a one-shot project and Boris was up to his neck in other book covers and assignments. The prospect of creating another calendar would lay dormant for some time until Boris was approached for a 1980 edition by the people at Workman Publishing. Once again, it was to be a collection of previously published work, but this time with an option for future installments should it prove to be a strong seller. As it turned out, it was very well received and each following year the publisher would visit Boris' studio to select a new batch of paintings.

This continued up until the late 80s, when Boris suggested that they try something new. Instead of reprinting old and somewhat randomly compiled material, why not make a collection of entirely new work? This was first done in his 1987 Fantasy Olympics Calendar, which depicted the various Olympic games being performed on a heroic scale, such as giants lifting mountain ranges and a woman high diving from a floating city. Needing a new angle for the following year, Boris painted a series based on the signs of the zodiac. The themed calendars were popular, but Boris found himself looking for a new concept each year which would yield enough material for a whole new series. Having had a life long interest in classic mythology, Boris decided this was a theme rich enough to mine indefinitely. He began illustrating his favorite myths from a number of cultures, ranging from Greek to Norse to Peruvian, and writing the accompanying text. It was shortly after this time that Boris met Julie, and his very first painting of her, "Alpnu," appeared in his 1990 calendar for the month of January.

The mythology theme went as planned initially, but after some years, Boris again found himself running short on material. It wasn't that he was running out of myths, but that the same myths seemed to be recurring. From culture to culture, he found too many similarities and felt that he would be repeating himself if he continued in this vein. As a result, Boris decided to make a return to the straight Fantasy format, though now with calendar exclusive images.

During these later years, Julie was building her own career and reputation as an artist and produced four calendars with multiple publishers. Her first two, in 1994 and 1995, were largely made up of portfolio work. In 1999 and 2000 she produced two more, these both being collections of various illustrations and personal paintings. Throughout the 90s, her work also appeared in several calendars by *Heavy Metal*.

It wasn't until 2001 that Boris and Julie would work together for the first time on a calendar. They released one featuring six images from each artist as well as a cover piece painted by both. On this cover, they took turns on the background, and each painted a figure on a separate board and digitally merged them. This cover was their first collaborative painting and an early experiment in the technique of digitally combining several layers. It would open the door for later joint efforts, particularly in future advertising jobs. It would also lay the groundwork for the following years of the Boris and Julie Fantasy Calendar, in which they each share an equal responsibility and put forth equal effort.

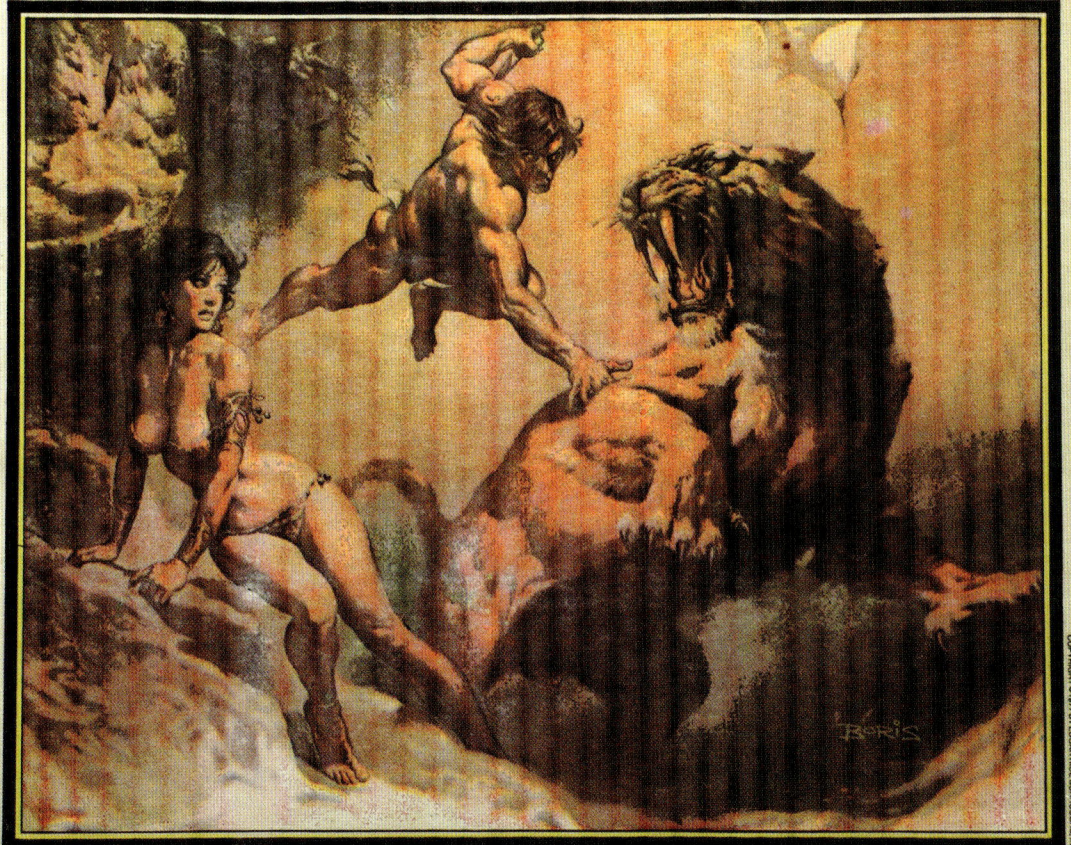

THE 1978 TARZAN CALENDAR
A YEAR OF ADVENTURE WITH THE LORD OF THE JUNGLE!
BALLANTINE BOOKS

Julie was thrilled to be working on the calendar alongside Boris, but also very intimidated. Being the newcomer to what was now a 20-year institution, she initially had difficulties in matching Boris's tone while still using her own voice. Looking back at her earliest contributions and then the years which followed, one can see her become more and more confident in her own style as she creates beautiful and unique work which complements rather than imitates. According to Julie, working with Boris on joint projects such as this has been one of the key steps in her exploring and developing her own identity as an artist, and this is what makes this calendar so special: the freedom that Boris and Julie enjoy while painting it. Most of the work which illustrators produce is dictated, at least loosely and sometimes very specifically, by their clients. Boris and Julie are no exception to this, except when it comes to their calendar. Here, they are free to let their imaginations roam in whatever directions they please. This provides an ideal breeding ground for

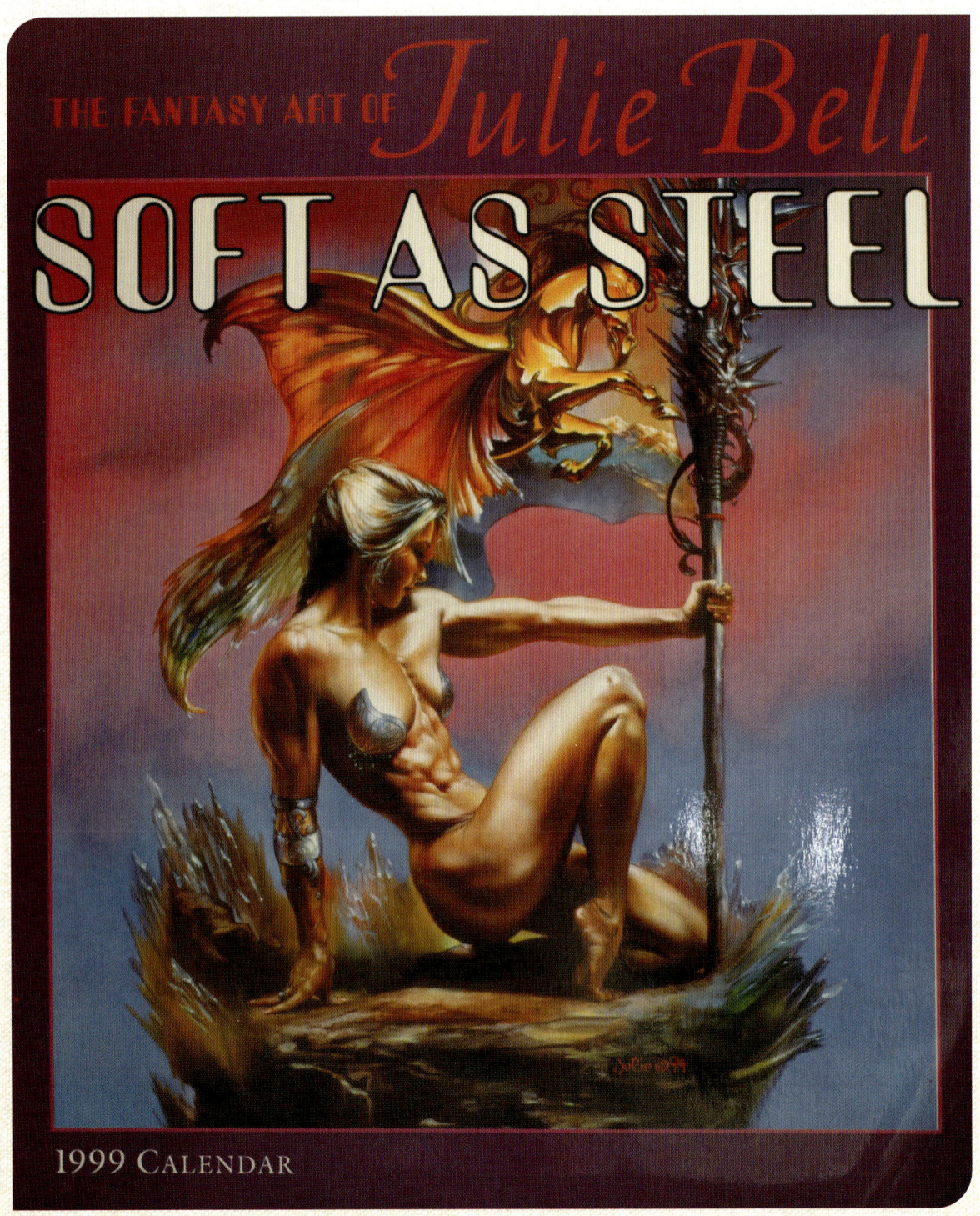

1999 Calendar

experimentation and artistic growth. Reviewing the past 27 years, or the past 9 in Julie's case, one can watch as the artists' personal styles and ideas evolve and transform in one year intervals, much like a time-lapse movie. Certain elements become solid, recurring themes while others drift about and eventually either die out or become new ideas to be experimented with further.

But where do these ideas come from? According to Boris and Julie, this must be the number one most frequently asked question by fans, and one which is often very difficult to give a straightforward answer to.

They both agree though that the simple answer is: everywhere. It can be anything from books, to the work of other artists, to even things so everyday and simple as the shape of a cloud. One of Boris' favorite ways to find inspiration is through macro photography, particularly of insects, when he can study parts of our world which are around us every day but too small to notice. But what really keeps the ideas flowing is keeping busy. The more that they paint and open their minds to new ideas, the more their brains get "switched on," as Julie describes it. When that happens, ideas will come at them from the most random and unexpected places. A story on the news, an overheard conversation, sometimes even just the patterns in a section of wallpaper can suggest an image which will eventually find its way into a painting. The key to their creative process is simply to keep moving all the time, allowing images to come naturally and not pressuring themselves in searching for ideas, which may actually stifle or cripple the creative process.

Possibly Boris and Julie's greatest source of creative stimulation is from their models. Once they have worked with a model several times and begin to form a reciprocal understanding, they can give less direction and concentrate instead on capturing the model's style

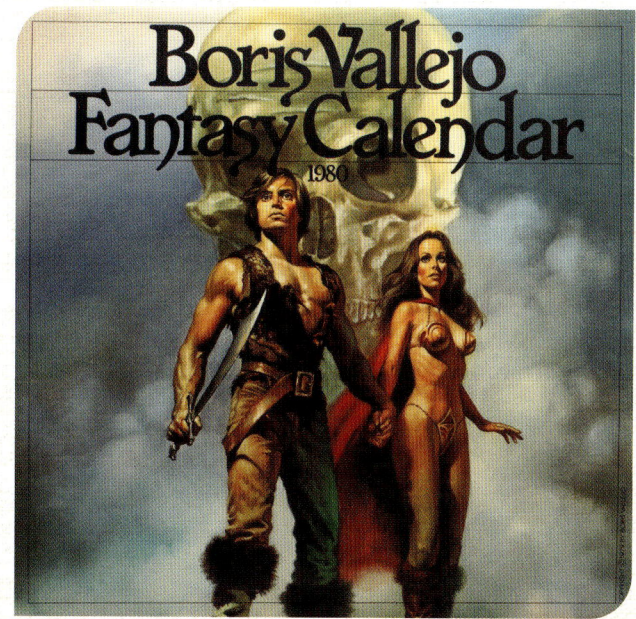

and energy. From here they'll build a story, working in an improvisational manner, with the model acting as muse. Sometimes this process extends all the way to the actual painting process, in which Boris or Julie will draw the figure onto their board and then begin building the world around them. Boris acknowledges that, while this is exciting to do, it may at times be taking unnecessary chances.

Although mostly at liberty to do as they please in these paintings, there are still considerations to be taken into account. Boris and Julie always bear in mind that each image of the calendar is going to be hanging on somebody's wall for a whole month, during which they'll likely be looking at it daily. Every piece needs to be thought of as a poster which one would choose to decorate their home or office with. Since people have different tastes, they try to keep themselves open to a variety of moods and themes in each year's collection. This concern has recently brought them back to reorganizing their overall process. Instead of letting each piece fall randomly into place, jumping from one to the next like one would on rocks in a river bed, Boris and Julie are now considering a return to the unified theme. Perhaps not so specific as Boris's mythology or Olympics, but still an overall plan to connect each piece and bring all of them together in a cohesive group. And so the evolution of the calendar, as well as the paintings themselves, continues…

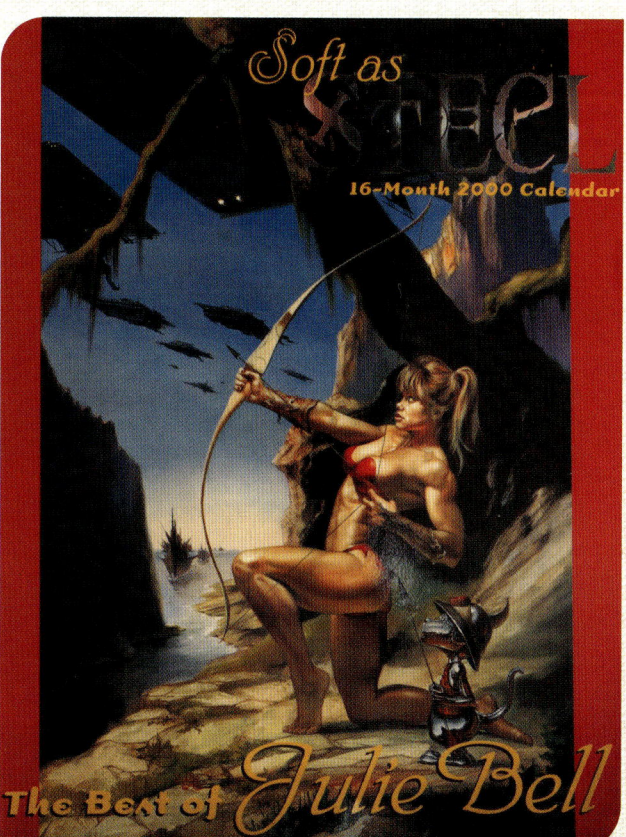

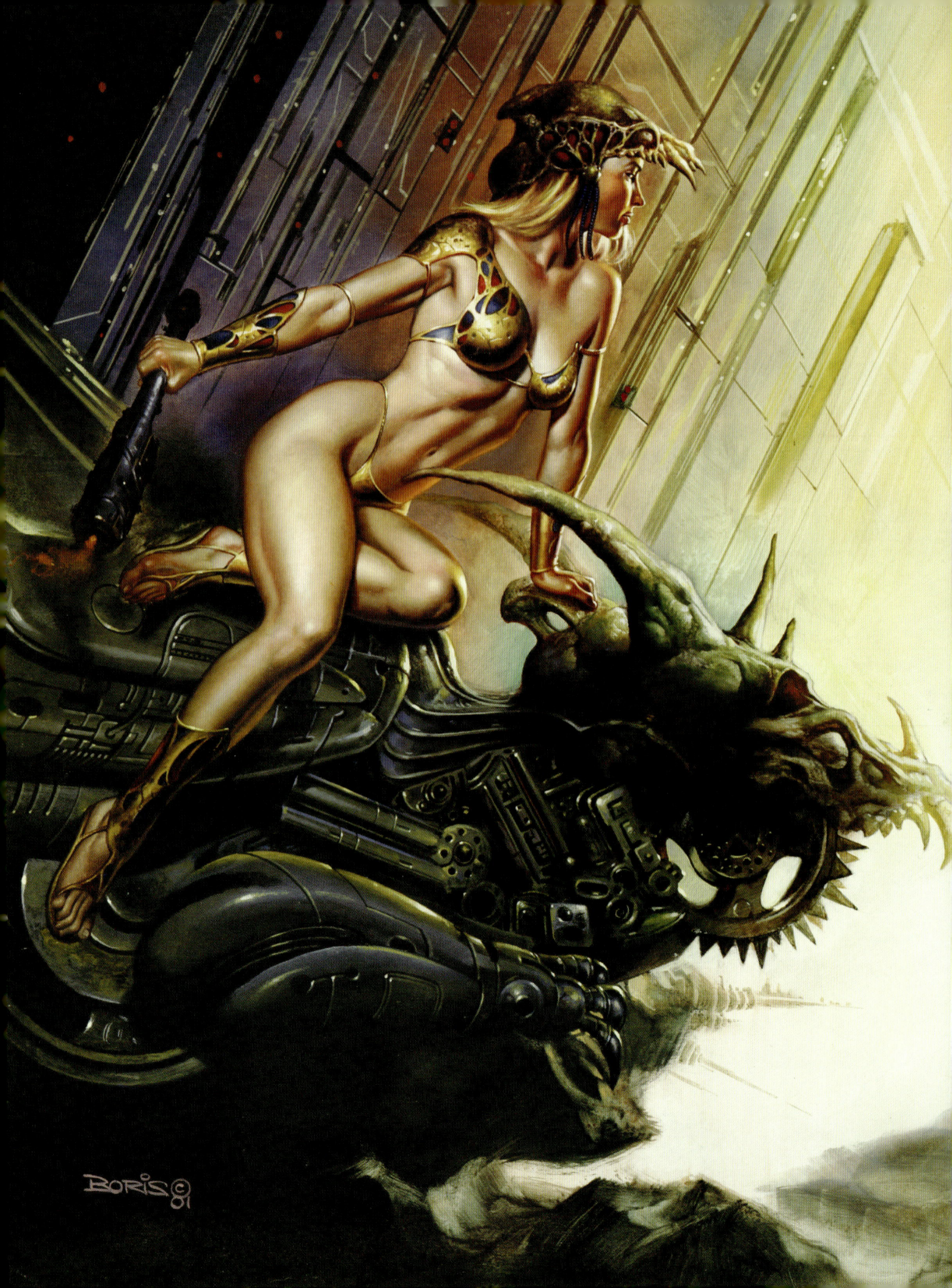

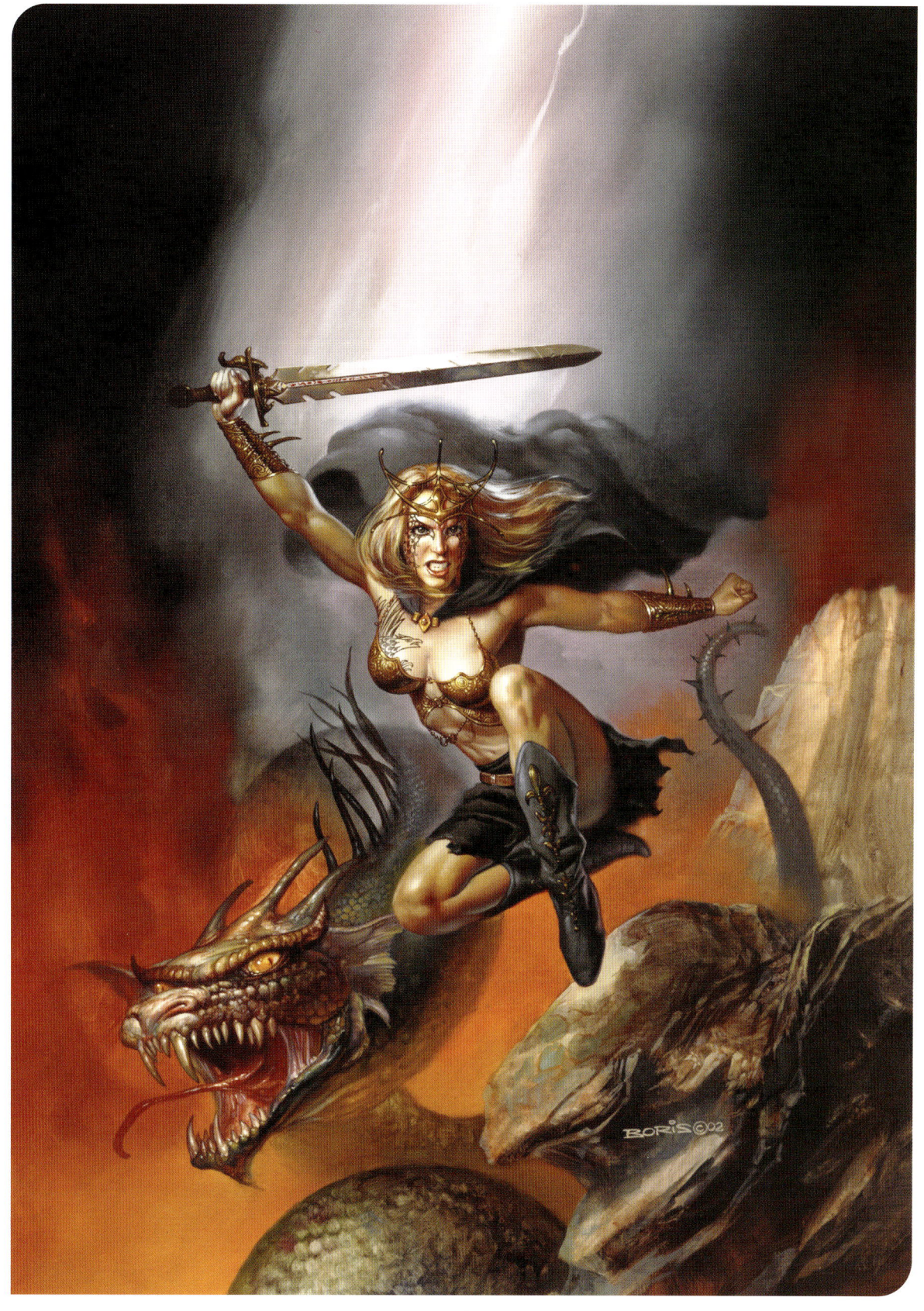

◂ I See Them Coming (Boris Vallejo)
MEDIUM Oil on Canvas

Ahead And Beyond (Boris Vallejo)
MEDIUM Oil on Canvas

IMAGINISTIX

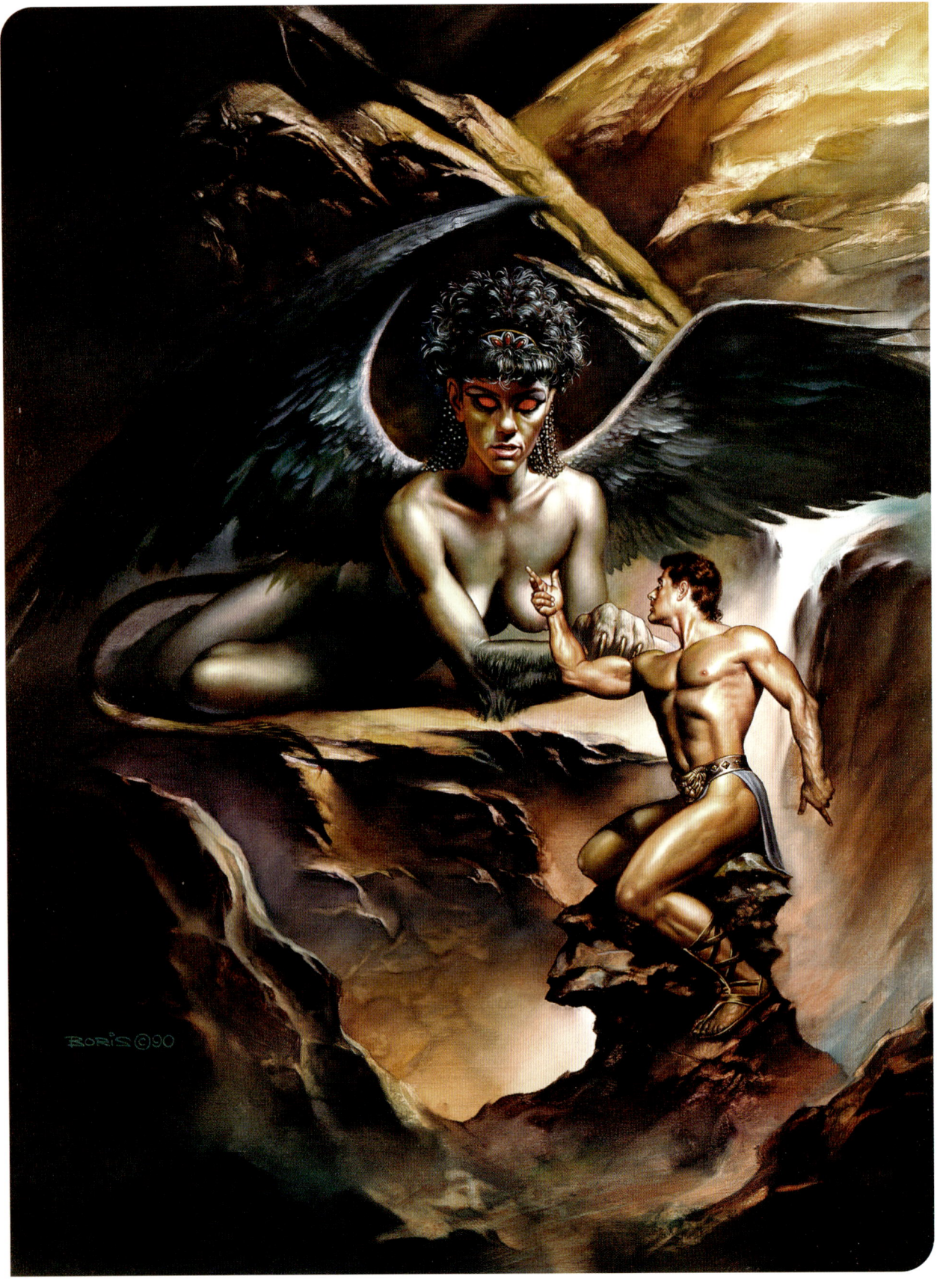

▲ Sphinx's Riddle (Boris Vallejo)
MEDIUM Oil on Canvas

Her Happiness (Julie Bell) ▶
MEDIUM Oil on Canvas

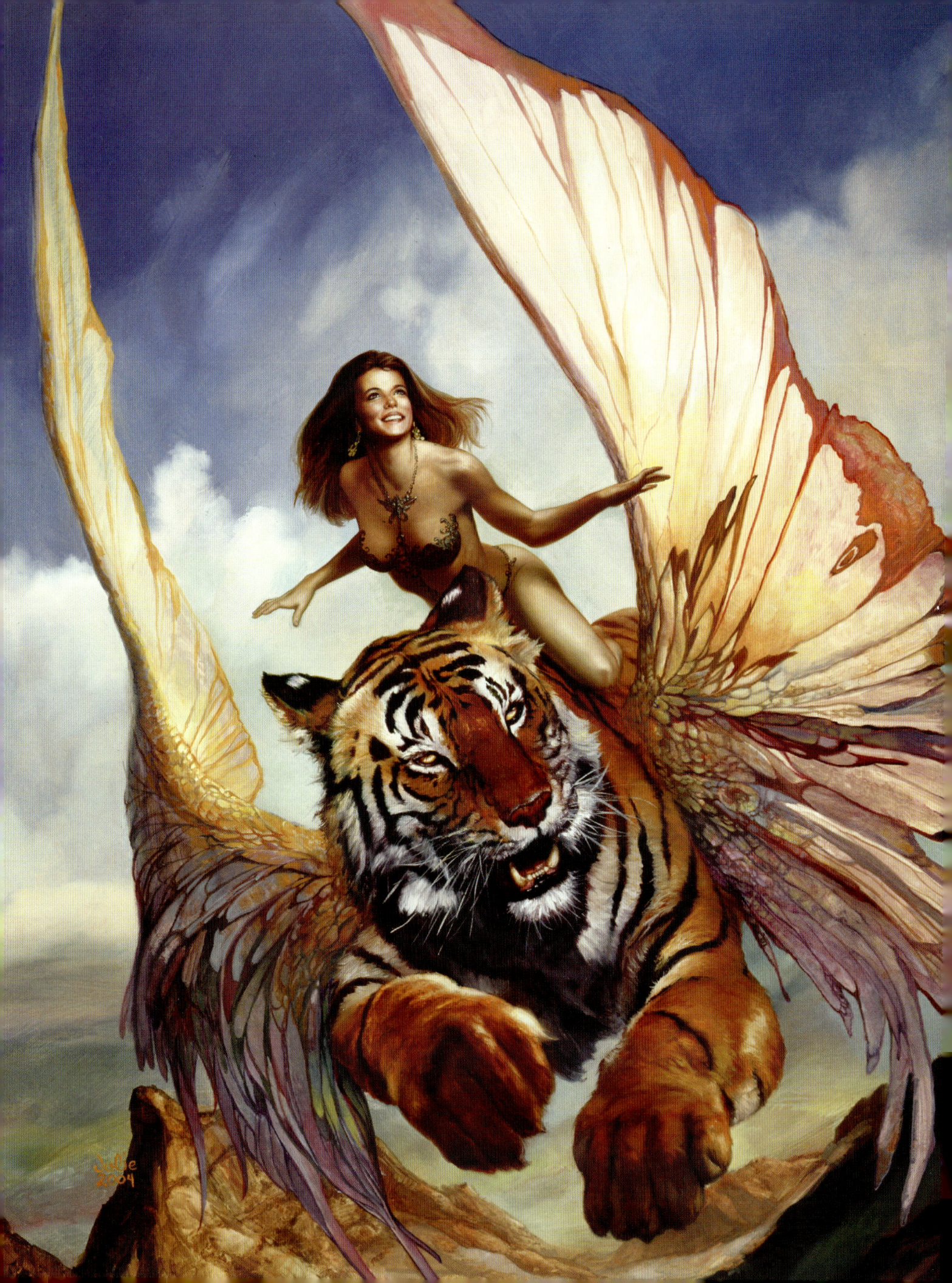

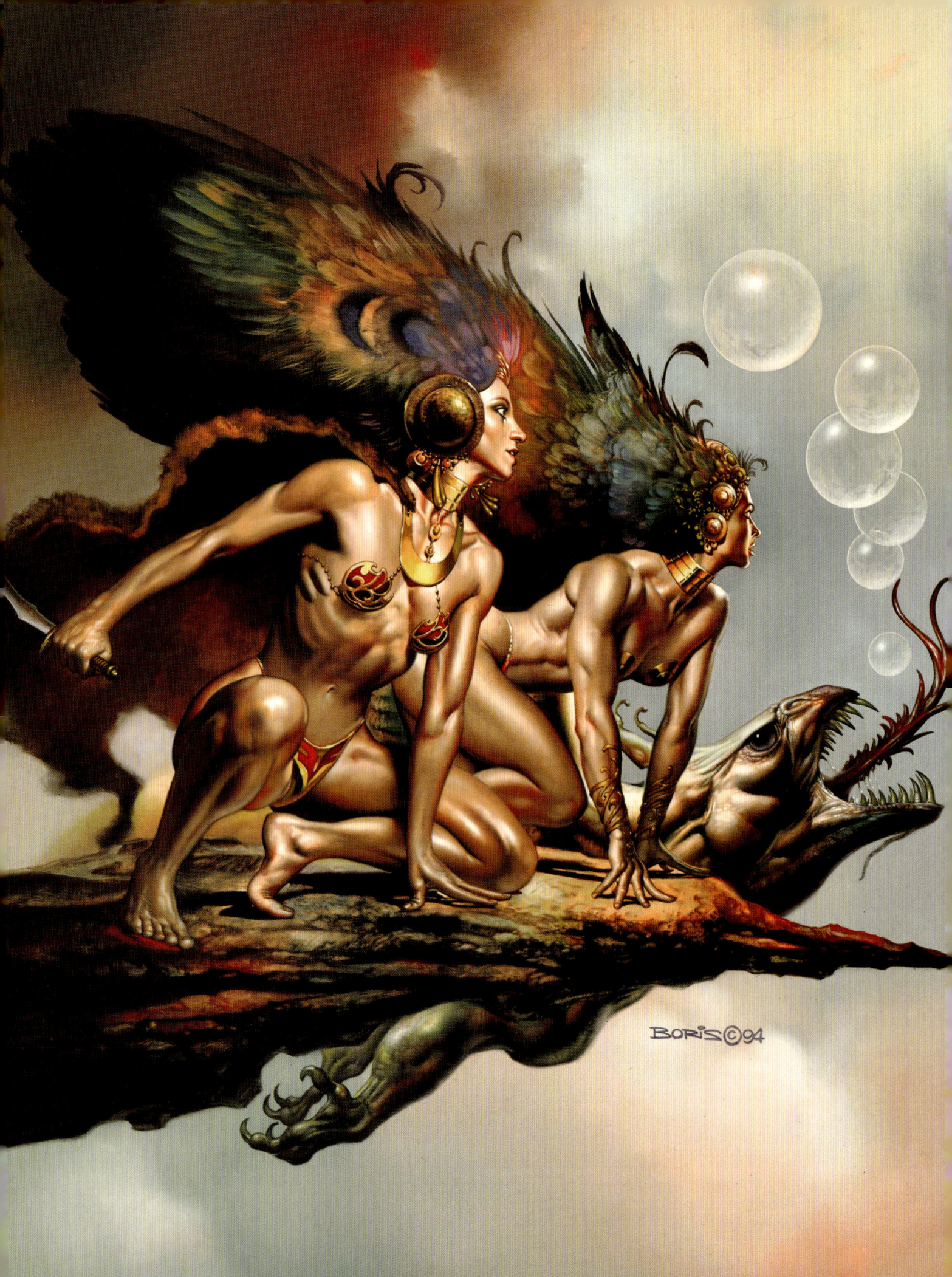

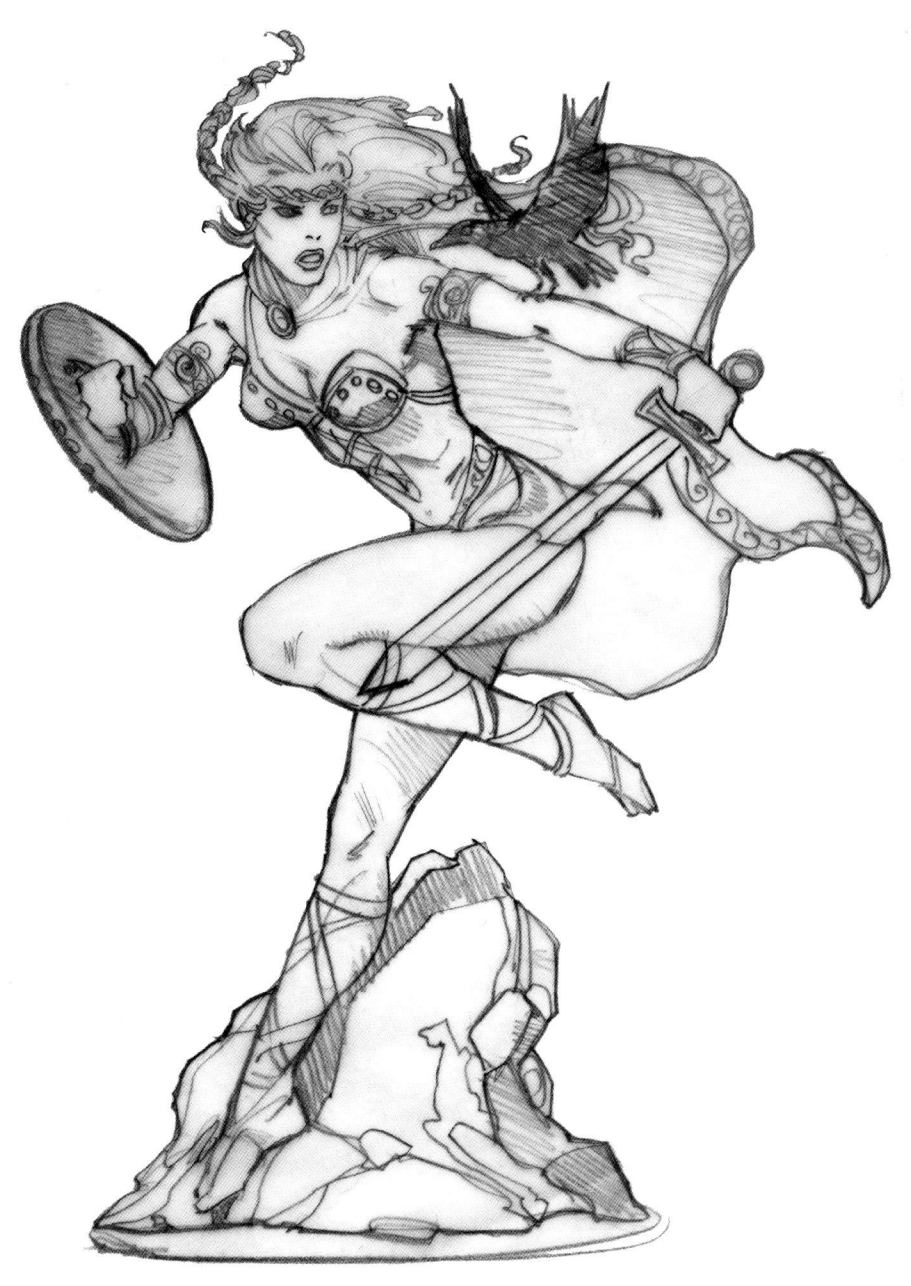

◀ Bubbles (Boris Vallejo)
MEDIUM Oil on Canvas

Sketch for Celtic Warrior sculpture
MEDIUM Pencil on Paper

IMAGINISTIX

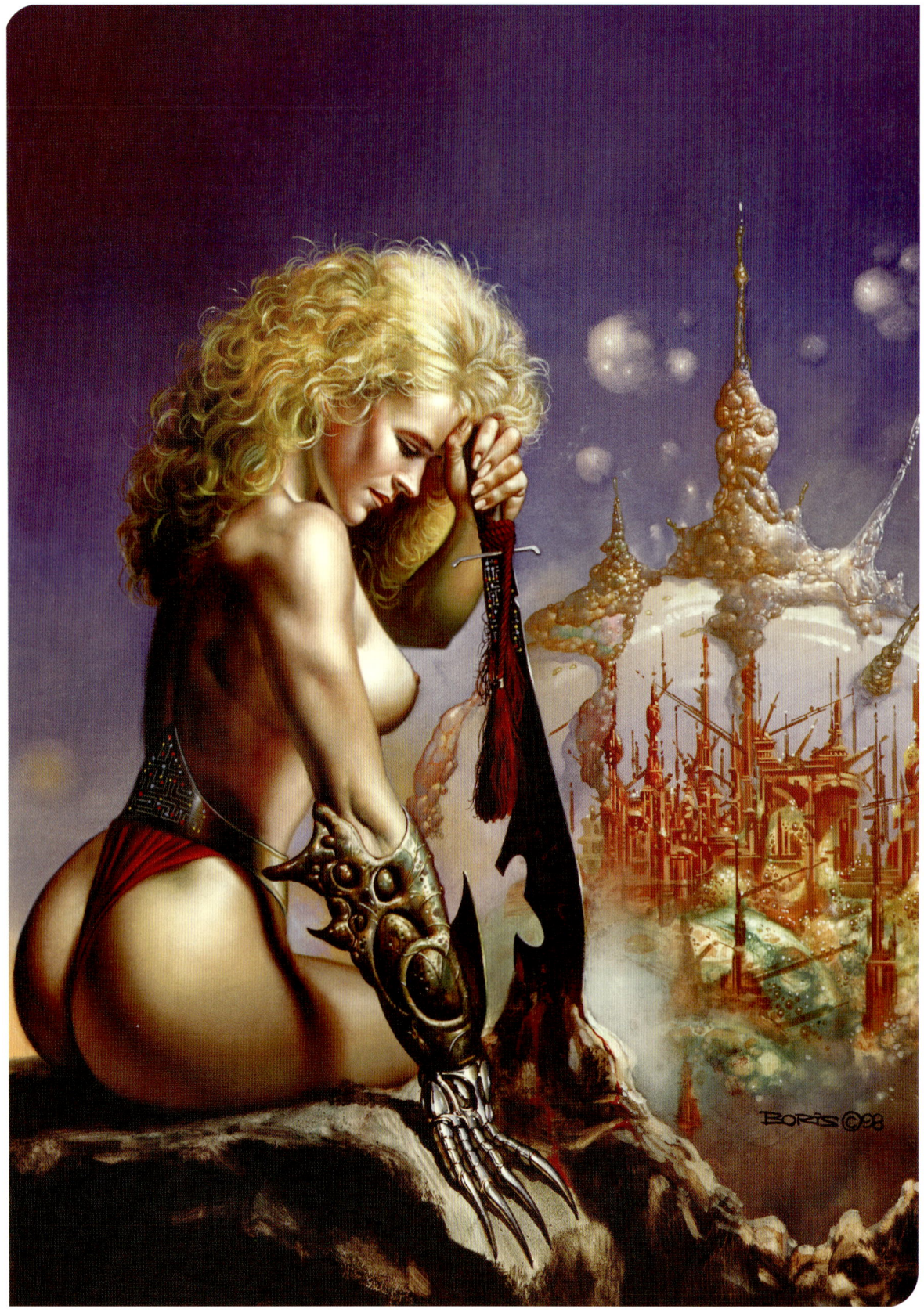

▲ Guardian Of The City (Boris Vallejo)
MEDIUM Oil on Canvas

Phoenix (Boris Vallejo) ▶
MEDIUM Oil on Canvas

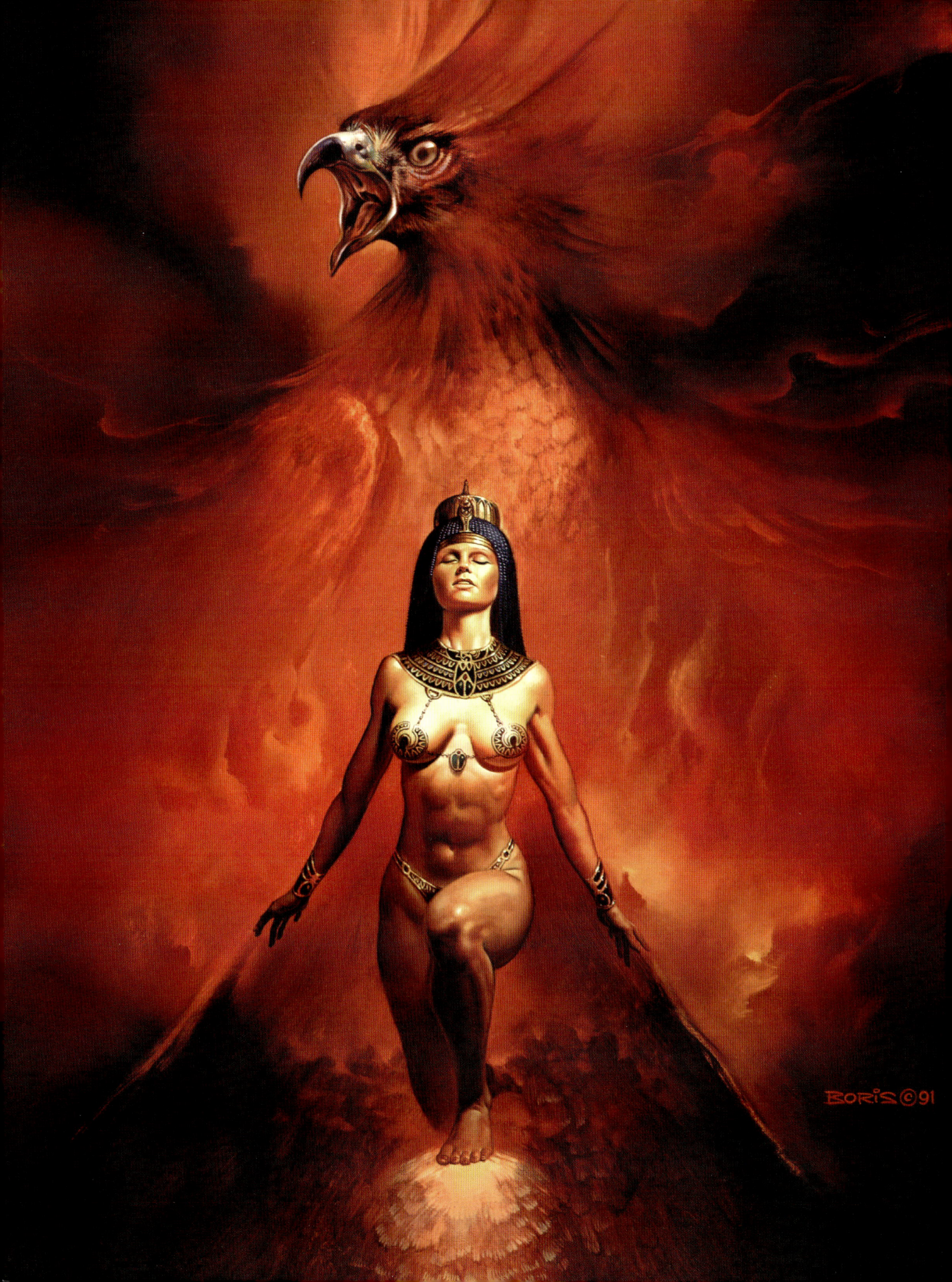

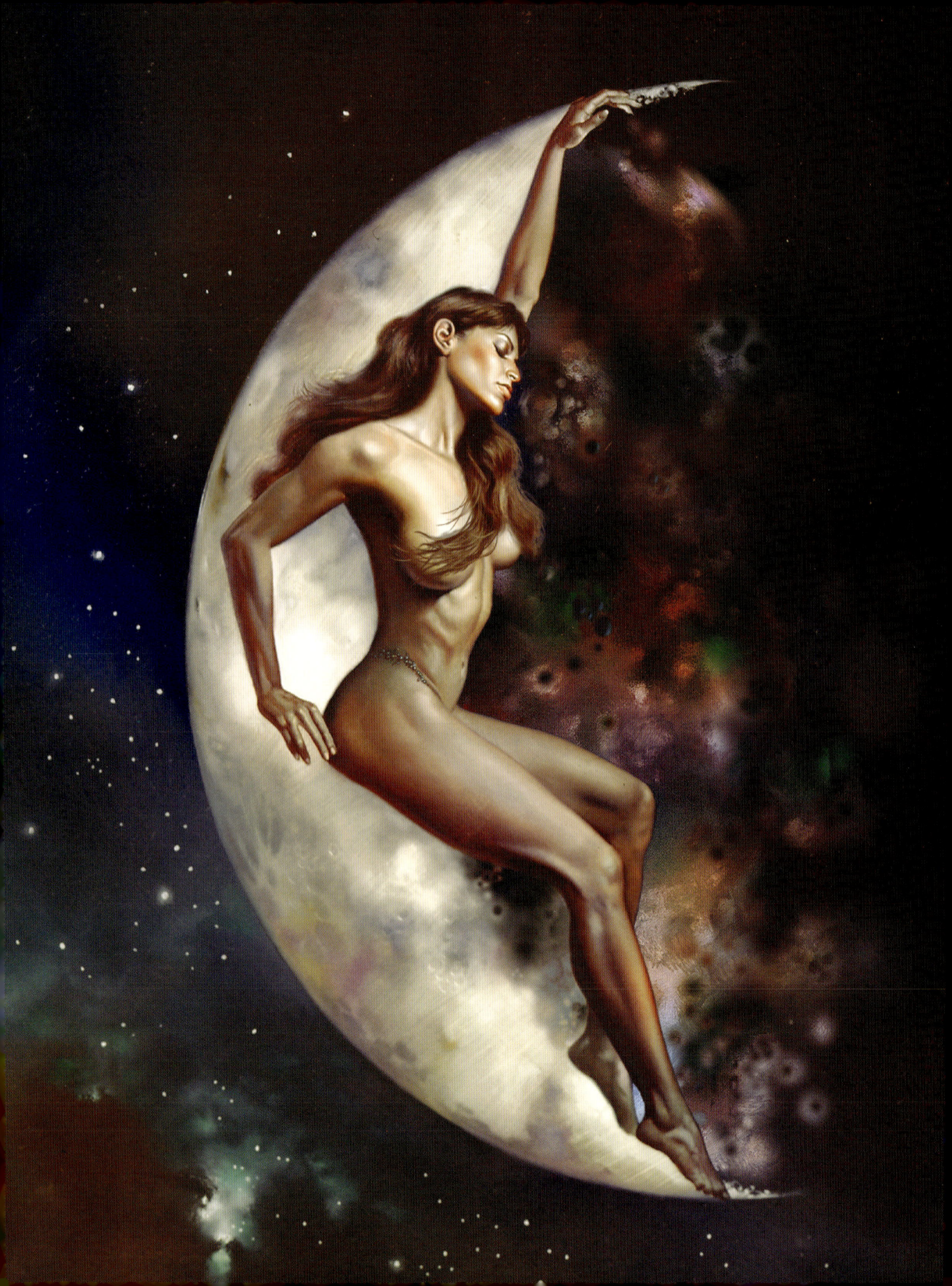

CALENDAR

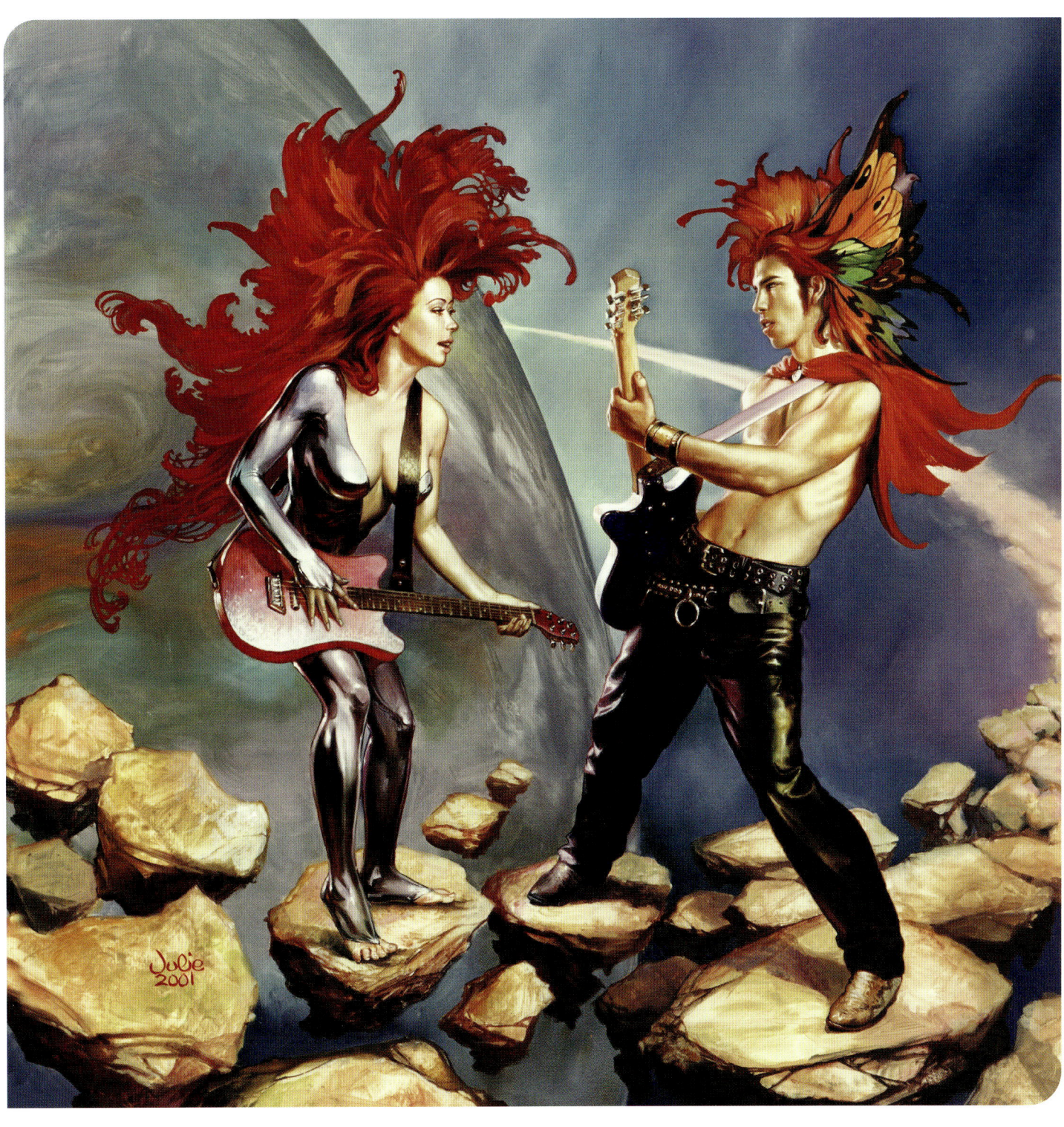

◀ Half Moon (Boris Vallejo)
MEDIUM Oil on Canvas

Star Rockers (Julie Bell)
MEDIUM Oil on Canvas

IMAGINISTIX

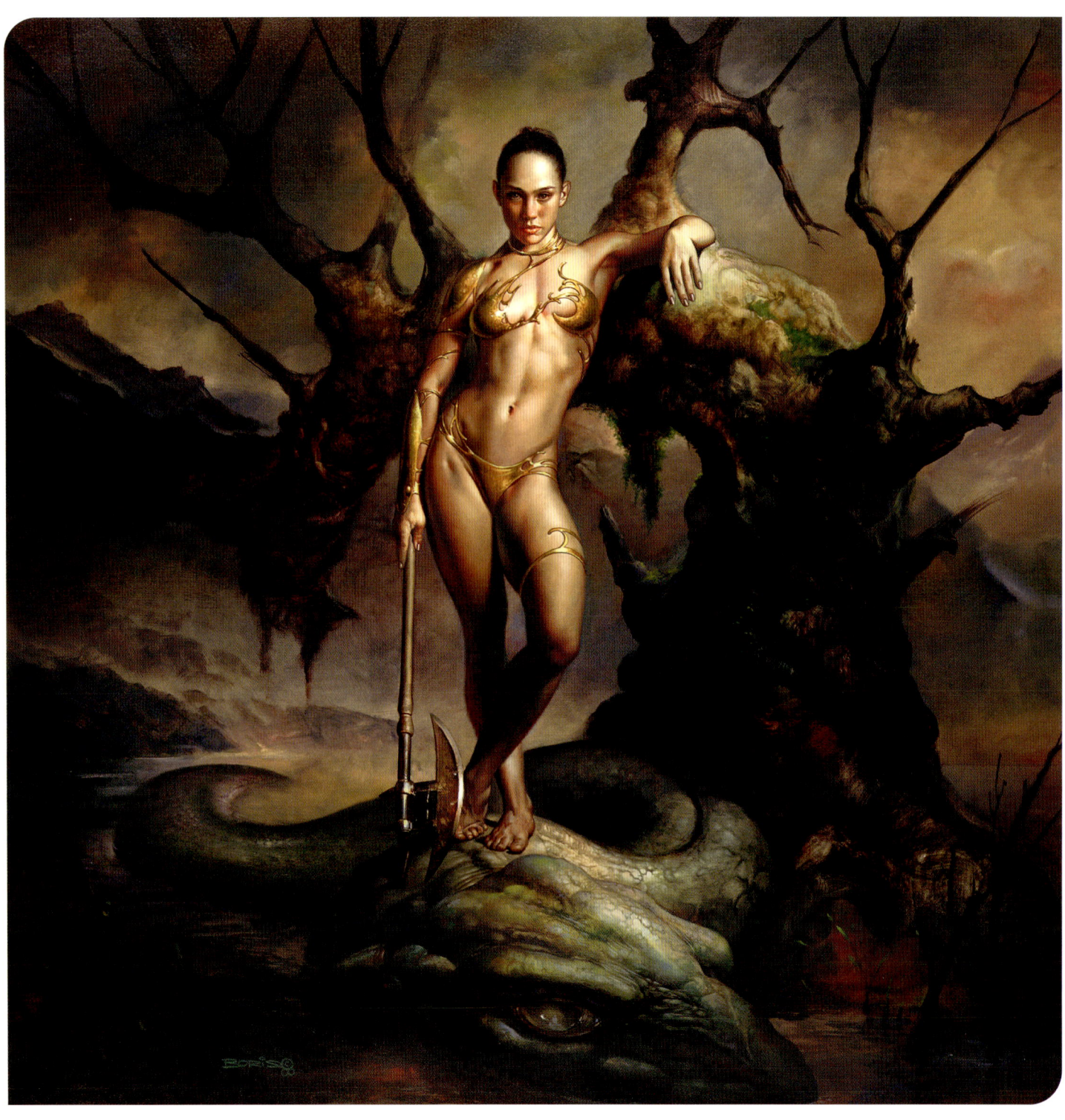

In Victory (Boris Vallejo)
MEDIUM Oil on Canvas

The Slayer (Boris Vallejo) ▶
MEDIUM Oil on Canvas

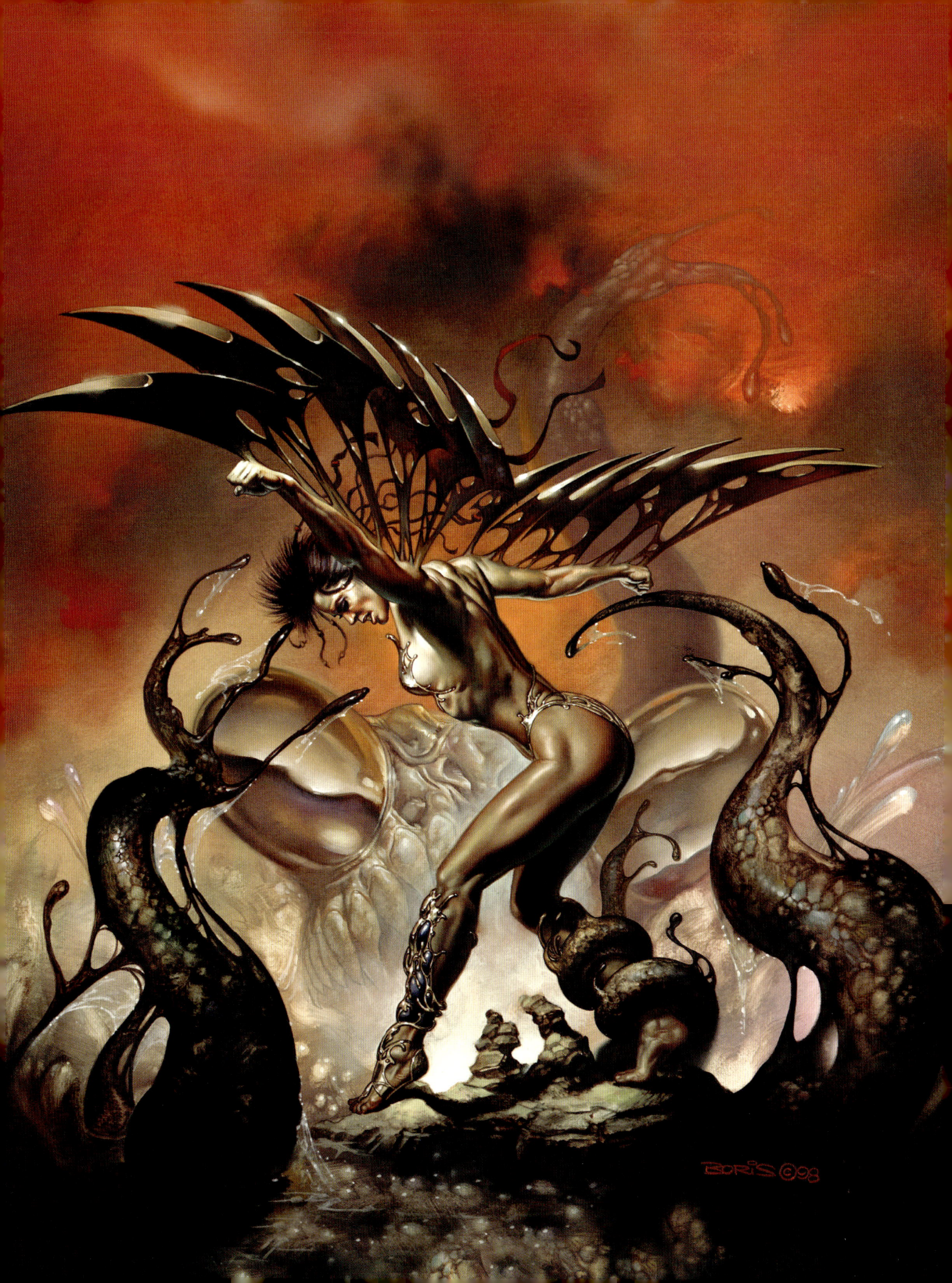

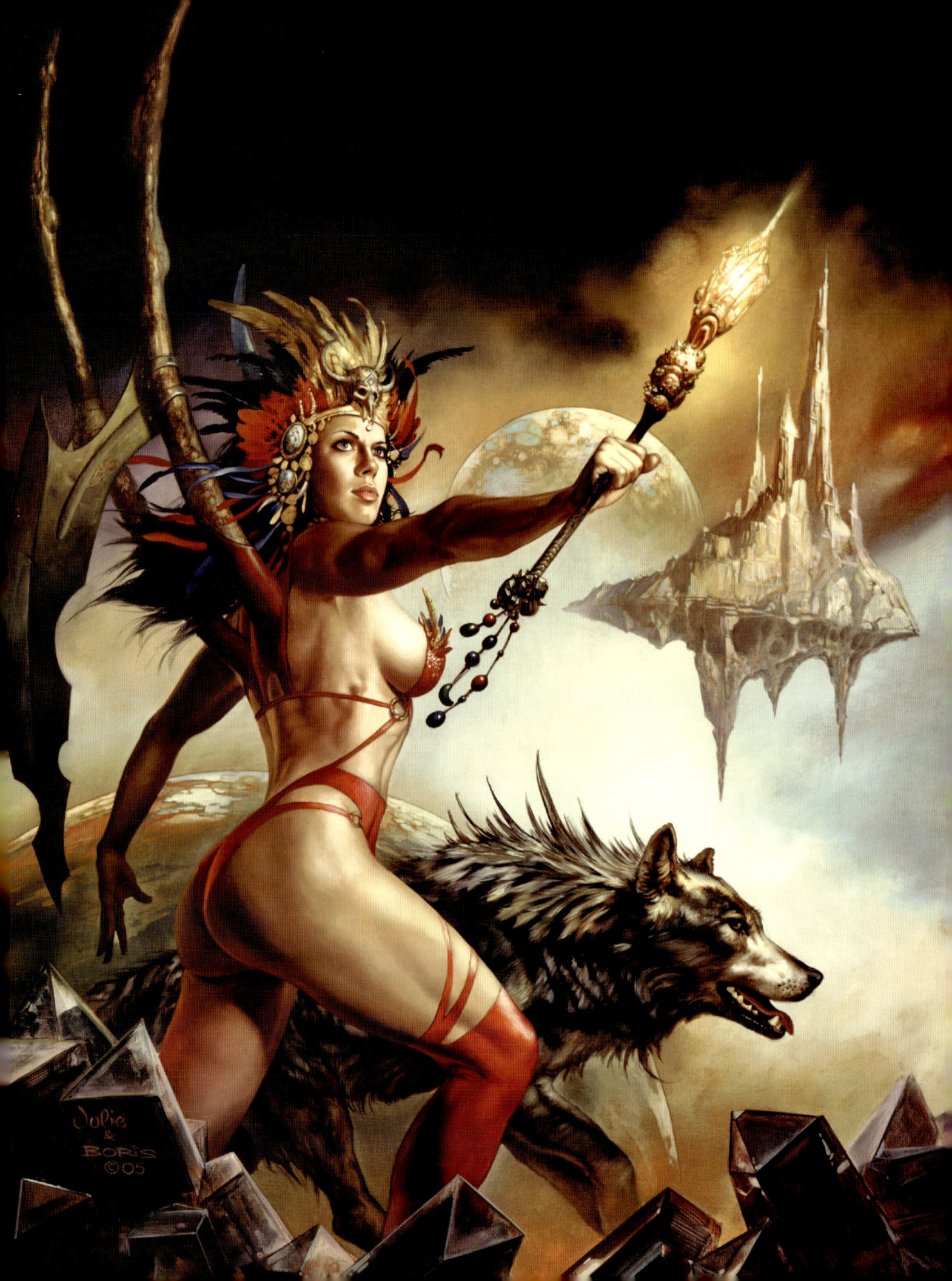

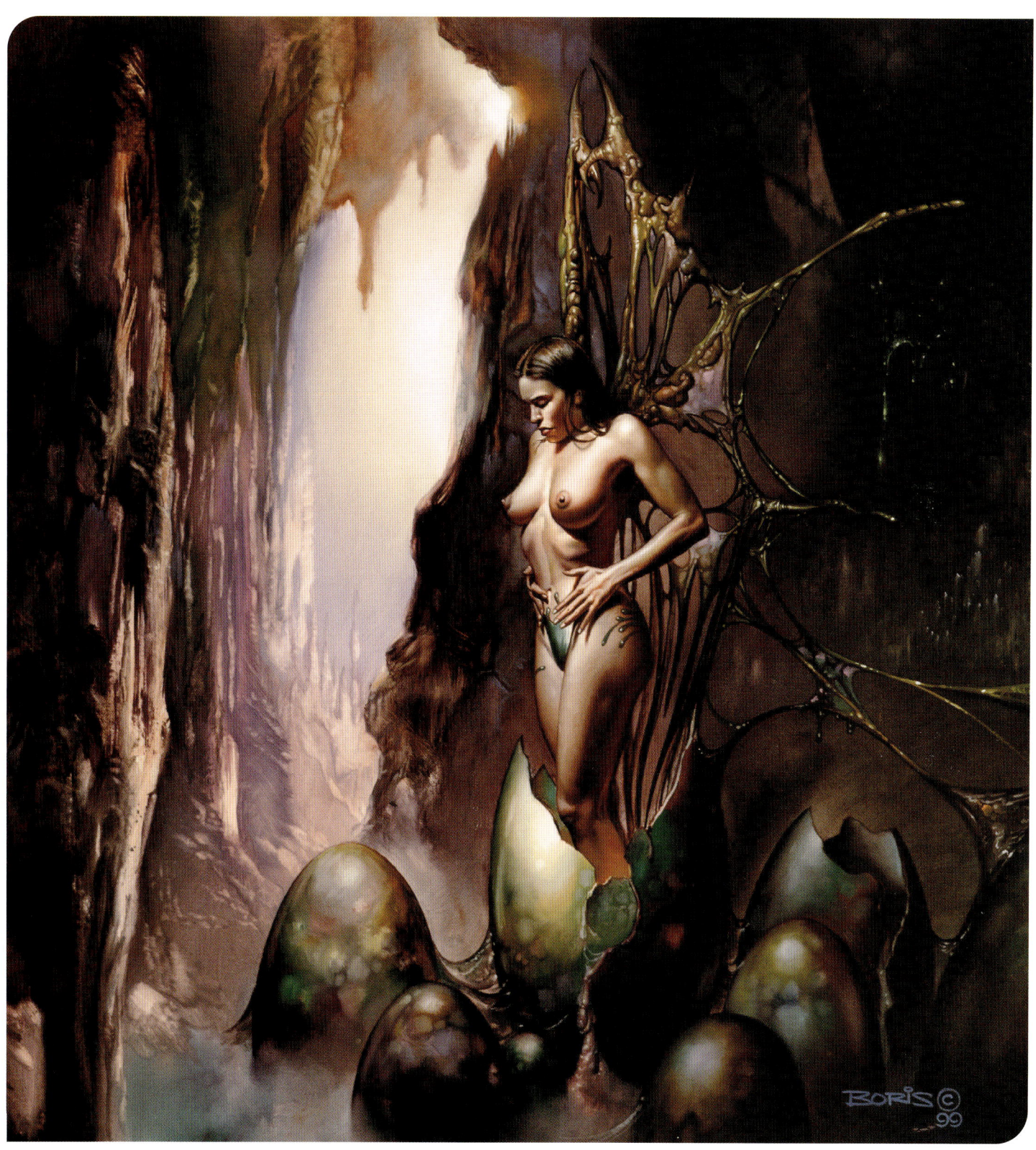

◂ Departure (Boris Vallejo & Julie Bell)
MEDIUM Oil on Canvas

The Hatchling (Boris Vallejo)
MEDIUM Oil on Canvas

IMAGINISTIX

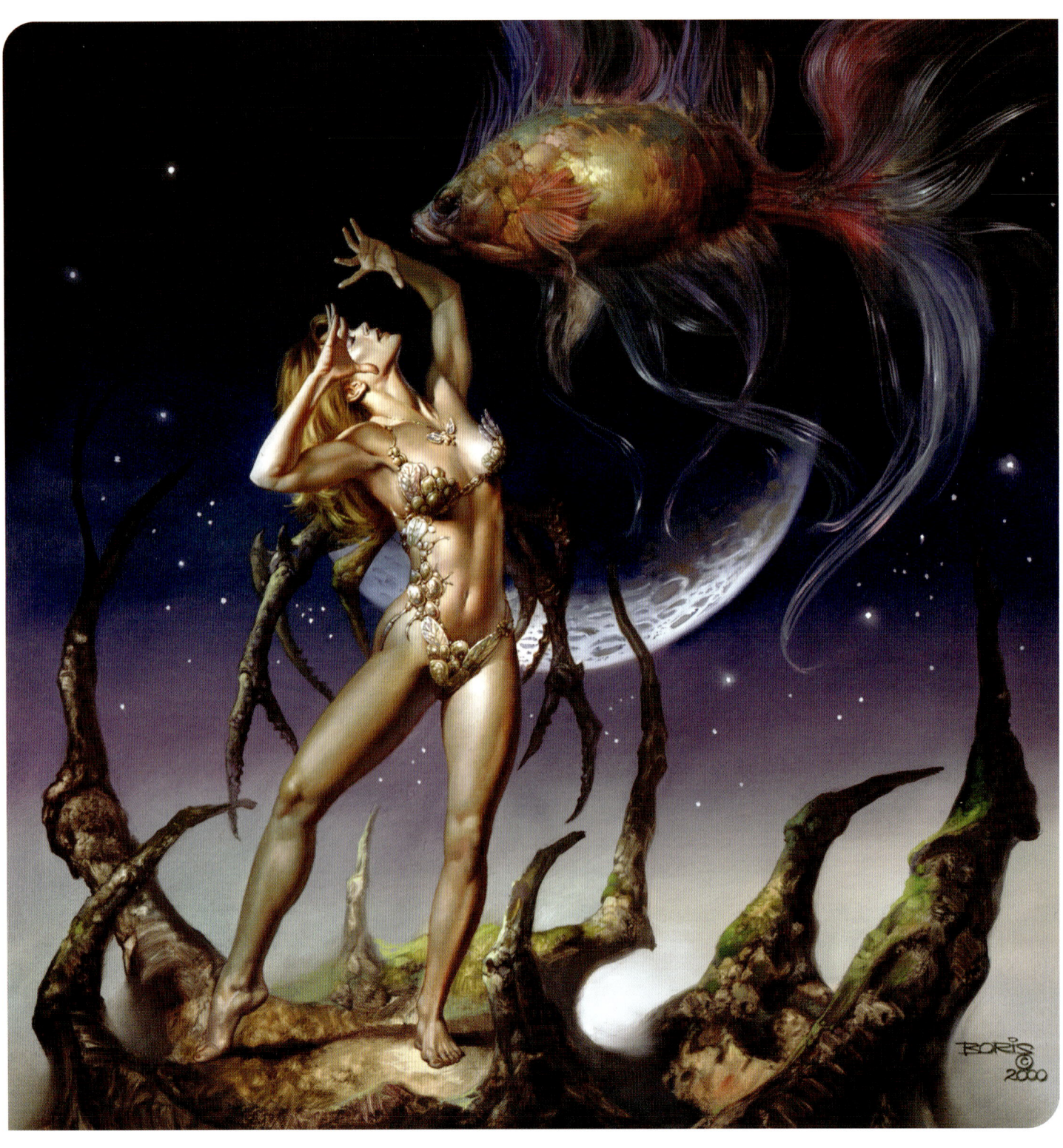

Wisdom From The Sea (Boris Vallejo)
MEDIUM Oil on Canvas

Transformation (Julie Bell)
MEDIUM Oil on Canvas

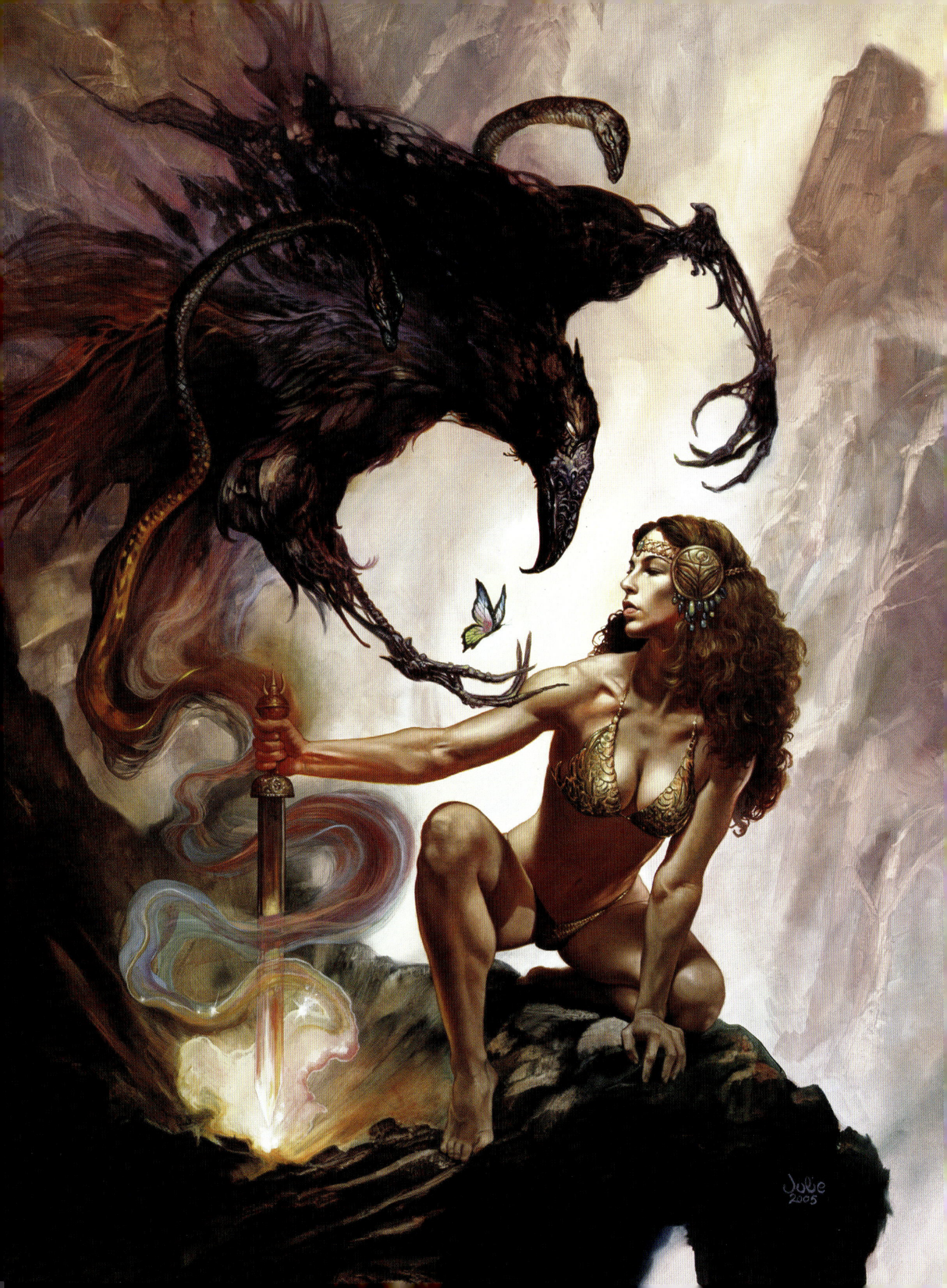

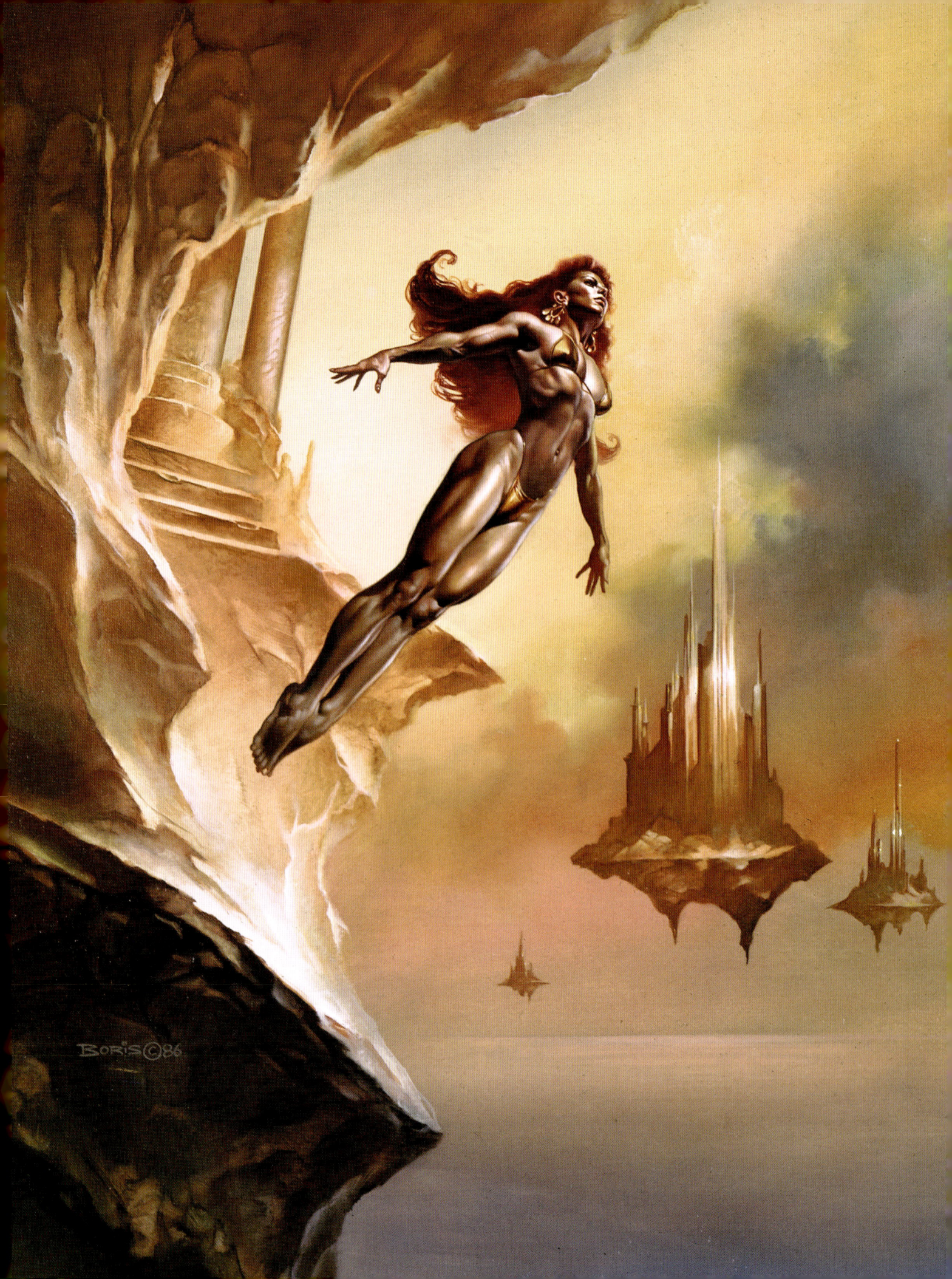

CALENDAR

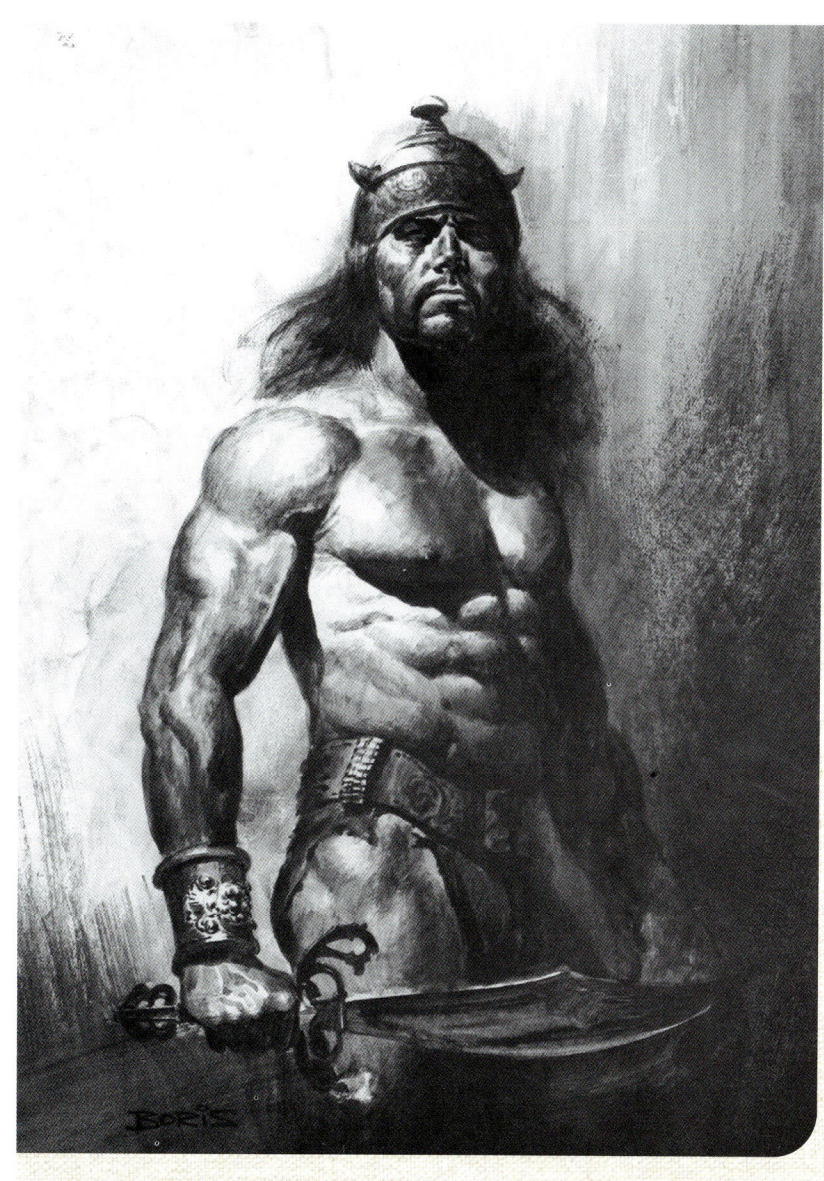

This sketch, actually an underpainting, was never resolved as a finished painting.

◀ Diving (Boris Vallejo)
MEDIUM Oil on Canvas

IMAGINISTIX

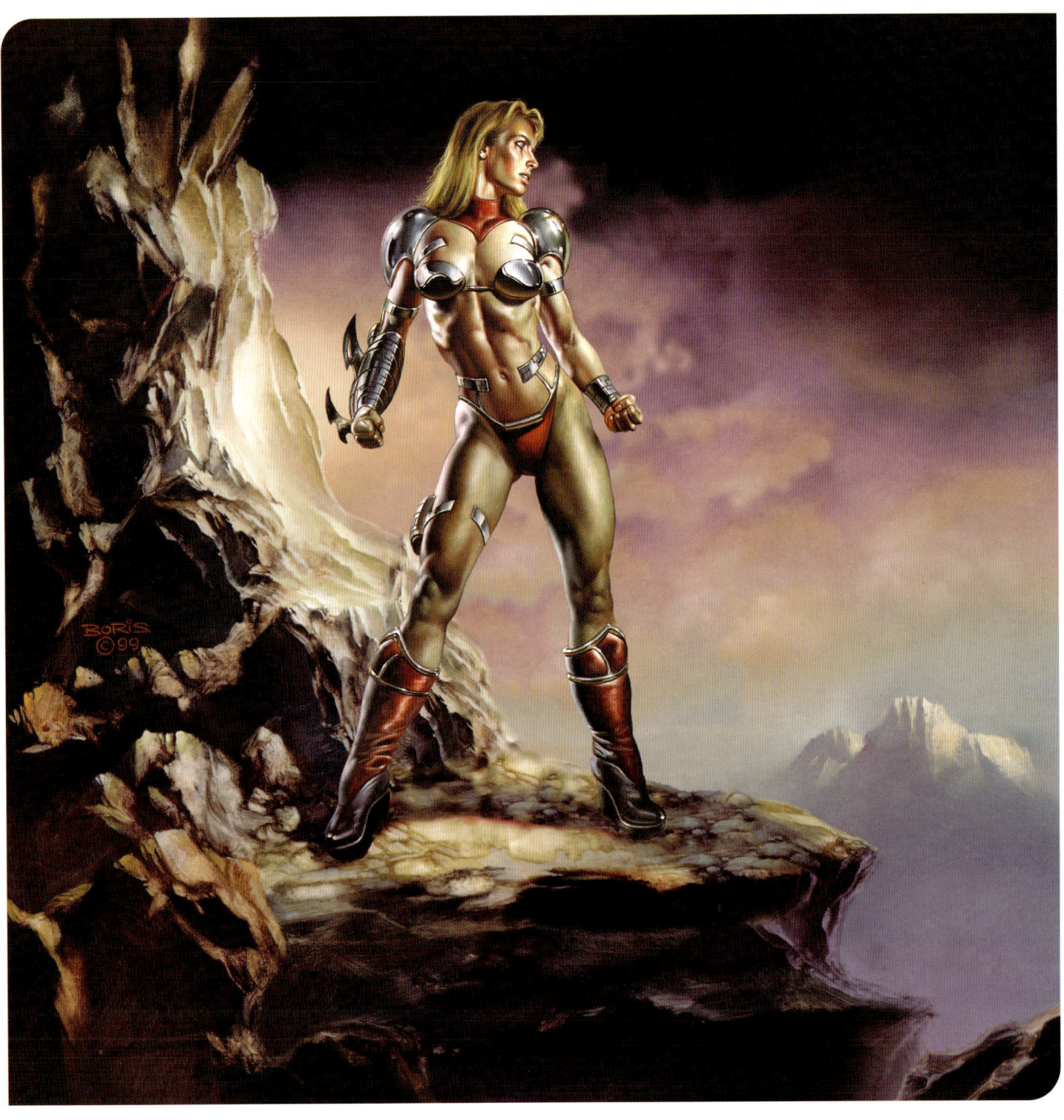

Triumphant (Boris Vallejo)
MEDIUM Oil on Canvas

Mermaid Couple (Boris Vallejo)
MEDIUM Oil on Canvas

CALENDAR

◁ The Beast Of The East (Boris Vallejo)
MEDIUM Oil on Canvas

37

IMAGINISTIX

Fairy Of The Dragon's Lair (Boris Vallejo)
MEDIUM Oil on Canvas

The Dryads (Boris Vallejo)
MEDIUM Oil on Canvas

BORIS ©91

◀ The Endless Journey (Boris Vallejo)
MEDIUM Oil on Canvas

IMAGINISTIX

The Vortex (Boris Vallejo)
MEDIUM Oil on Canvas

Angel (Boris Vallejo)
MEDIUM Oil on Canvas

CALENDAR

◁ Sea Castles (Julie Bell)
MEDIUM Oil on Canvas

Under The Bridge (Julie Bell)
MEDIUM Oil on Canvas

45

IMAGINISTIX

Shooting scenery while hiking with friends in Massachusetts.

The Gift (Julie Bell)
MEDIUM Oil on Canvas

◀ Cat Of Nine Tails (Boris Vallejo)
MEDIUM Oil on Canvas

Hechicera (Boris Vallejo & Julie Bell)
MEDIUM Oil on Canvas

IMAGINISTIX

Awaiting The Battle (Boris Vallejo)
MEDIUM Oil on Canvas

Rescue Of The Dragon Baby (Julie Bell)
MEDIUM Oil on Canvas

Jubie
2004

CALENDAR

◀ Cruel Fate (Julie Bell)
MEDIUM Oil on Canvas

One of many sketches done for The Franklin Mint
MEDIUM Pencil on Paper

53

IMAGINISTIX

Star Child (Julie Bell)
MEDIUM Oil on Canvas

CALENDAR

◀ Underwater (Boris Vallejo)
MEDIUM Oil on Canvas

Andromeda (Boris Vallejo) ▲
MEDIUM Oil on Canvas

57

IMAGINISTIX

Masked Fairy (Boris Vallejo)
MEDIUM Oil on Canvas

Hercules (Boris Vallejo) ▶
MEDIUM Oil on Canvas

58

CALENDAR

◀ Astarte (Boris Vallejo)
MEDIUM Oil on Canvas

A magical friendship between an innocent child and a powerful, protective dragon
MEDIUM Pencil on Paper

61

IMAGINISTIX

Bronco (Boris Vallejo)
MEDIUM Oil on Canvas

Let 'Em Come (Boris Vallejo)
MEDIUM Oil on Canvas

CALENDAR

He Waits For Her (Julie Bell)
MEDIUM Oil on Canvas

IMAGINISTIX

Discovery (Boris Vallejo)
MEDIUM Oil on Canvas

Freedom (Boris Vallejo)
MEDIUM Oil on Canvas

ADVERTISING

Lima, Peru, in 1959. Boris was a skinny, shy teenager with a slick pompadour who had just started work in the field of advertising. A local movie theater would project slideshows of ads on screen before the films rolled, and seventeen-year-old Boris displayed the talent and ambition to become the sole provider of artwork for them. His clients were Lima's merchants, restaurants, and other assorted businesses. Here, Boris quickly gained a hands-on education in many technical aspects of illustration and design, such as planning layouts, lettering by hand, and creating the artwork. Boris's biggest inspirations at the time were the ubiquitous paintings by Art Fitzpatrick and Van Kaufman that he saw in advertisements for Pontiac automobiles.

Boris was going to art school, and taking on illustration work wherever he could find it. It seemed a stroke of good fortune when an acquaintance named Sydney Henderson became head of Peruvian advertising for Philco, the electronics company. Sydney hired Boris to draw ads for their radios, televisions, and other gadgets. After three months of work, however, Boris had still not received a single paycheck. Accompanied by his father, Americo, a lawyer, and sister, Patricia, for moral support, he went to the office to straighten out this oversight, only to find that Sydney had fled the country after being fired for embezzlement. Alas, Boris was never paid.

In 1962, Boris began work for the Peruvian branch of McCann Erickson, an advertising company. His duty was to provide illustrations of various household items for retail advertising. The art director, Manuel Guevara, must have seen a unique talent in Boris, for he urged him to leave Peru and pursue a career in New York. Jorge Vera, a friend and fellow artist at the firm, left for the US in 1963 and Boris tried unsuccessfully to contact him for information on the American work situation. With no friends or associates in America, and almost complete ignorance of the English language, Boris left for New York in 1964.

For two nights, Boris slept in New York's subway trains, ceaselessly traveling the length of Manhattan. He would emerge into daylight at 42nd street for lunch. Today, when asked if he had any kind of plan for finding work or a roof over his head, his reply is: "No. I never had a plan. My thought was, 'Something is going to happen.'" Miraculously enough, something did happen. While eating lunch, he overheard some people speaking Spanish. They were fellow Peruvians and offered Boris a room with them in The Bronx, breakfast and lunch included, for $20 a week. Boris had $80, and therefore a month to find work. Luckily, fortune would shine on him with a series of unlikely coincidences.

A Peruvian couple from Connecticut met Boris when they were on their honeymoon in The Bronx, and they told Boris of a Peruvian art director named Raul Grande. Raul worked for Topps, a chain of department stores based in Hartford, Connecticut, and so Boris went to Connecticut seeking work. He was hired and began working in the same mode as he did at McCann Erickson in Peru. An artist cousin of

Conqueror of the depths

Raw power to get the job done. Muscle. Guts. Endurance. Renowned throughout the oil patch for its ability to take the load and hold it. That's a Detroit Diesel engine.

Order one wherever you need 48 to 1800 tough, long-lasting horsepower. For virtually every oil field job. Drilling. Workover. Formation fracturing. Gen sets. Crewboats.

Sold and serviced by professionals throughout the world. Distributors and dealers who know their business... and yours.

For more information, call toll-free 1-800-521-0121 (in Michigan, 1-800-572-2424). Or write: Don Downham, Sales Manager, Detroit Diesel Allison, Division of General Motors, P.O. Box 81, Birmingham, MI 48012.

The Detroit Diesels

Detroit Diesel Allison | GM

The Mystery Shift by COLEBROOK

The mystery shift meant tumultuous things to many people: To Colebrook it was a wild and runaway thing so desirable it wouldn't stay. To Ann Fairfax, beautiful traveler, it meant pursuit and passion in a Gothic garden. To Wolf Baron, merchandise manager, it was so totally different in easy-care Dacron® polyester doubleknit. He knew he could possess it only briefly. To you the mystery shift can mean momentous spring sales if you order instantly. Colebrook Inc., 1407 B'way, N.Y.

Raul's came to work alongside Boris at Topps, and he was none other than Boris's old friend and colleague from Lima, Jorge Vera. Topps relocated to New York in 1965 and Boris, Jorge, and Raul moved into a two-bedroom apartment on 14th Street in Manhattan's Meat Packing District.

Boris spent his days from nine in the morning until nine at night at the company drawing board, illustrating a seemingly endless series of pots, pans, refrigerators, and other goods. It was extremely tedious and, he says, "A pain in the butt." Boris quit Topps in 1967, moved to bohemian Greenwich Village, and went freelance. With his Topps connections, he found it easy to get steady work from various clients in New York, drawing black and white renderings for retail advertisements. Occasionally, he worked in color with gouache paints. Boris found that as a freelance brush for hire, he could make ten times his old salary. The hours were harder though, and Boris would often work two or three days straight, catching an hour of sleep when he could.

Sometimes he had to do as many as thirty illustrations overnight. There was one instance in which he accidentally dropped his folder full of the day's reference photos onto the subway tracks and had to wait until two in the morning to retrieve them. He then rushed back to his home studio to spend all night drawing. In 1976, Boris bid farewell to his career in retail advertising. He was quickly becoming a popular book cover illustrator, doing fifty-three covers for Ace and Ballantine in his first year, and could no longer find the time to draw hairdryers, grills, and microwaves.

High profile corporate advertising work eventually began coming in from many companies that wanted to spice up their public image. Amongst the most memorable print ads of the 1980s were Boris's award-winning paintings for the clothing company Chess King, striking portraits of ultra-cool young men sporting the brand, often accompanied by an alien woman or mystical beast. It was also in the '80s that Boris's illustrations of bodybuilders hoisting Joe Weider's sports drinks into the air graced the pages of *Muscle & Fitness* magazine. This was how Julie Bell was first exposed to the art of Boris.

When Julie first saw one of Boris's paintings in an exercise magazine, she was stunned. In fact, she couldn't quite comprehend what she was looking at. It couldn't be a photograph, but it didn't look like any kind of painting she had ever seen before. She remembers reacting the same way to Norman Rockwell paintings in her youth. It wasn't until four or five years after this first encounter that Julie met Boris in person and realized that he was the man who painted that memorable image.

Julie's start in the business of advertising came at the age of sixteen, while attending community college, having graduated from high school early. She lived with her mother and sisters in Atlanta, Georgia. This was 1974 and worlds away from Boris in New York, a year after he began painting his first fantasy illustrations for comic books. Julie was hired to do the in-store advertising for an arts-and-crafts store. Her boss asked her if she knew how to letter signs, to which she answered, "I guess so" and promptly pored over all of the store's books on sign lettering. A few years later she was living in frostbitten Marquette, Michigan, where she found a job as a secretary at the local newspaper. After six months she worked her way up to the art department, organizing the layouts for the ads and doing occasional designs and spot illustrations. While working at various non-art related occupations during the '80s, Julie continued to hone her craft and emerged a professional in 1990, with a cover

illustration for Heavy Metal magazine. Her first advertising work was from the firm Britton Advertising in 1992.

Today, Boris and Julie do almost all of their ad work together, as a collaborative effort. The advertising world has always been fast paced, and the digital revolution in image making has kicked it up to even greater speeds. In a typical scenario, Boris and Julie will work on an ad simultaneously, each painting some of the figures on separate panels using traditional painting techniques, and then digitally join them together with the aid of Photoshop. This allows a job to be completed twice as fast and makes revising the work a simpler task, should changes become necessary. It also allows a client to commission a piece that is convertible between formats, such as an ad that is to appear vertically in magazines and horizontally on billboards. Boris and Julie admit that when they do this kind of work, they miss having a finished physical painting to hold at the end.

This hybrid technique can be seen in their paintings for Nike. The image "Temptation" is unique among Boris and Julie's work, in that the foreground figure of LeBron James is a photograph merged into the painted world. This was the client's vision for the piece and it is interesting to see how well the painted background and figures hold up, maintaining an impression of reality next to the photo.

The mermaid series was for a British advertising company and particularly excited Julie. The ads appeared on UK billboards, in Underground stations, and on buses. She was thrilled to know that the mermaids would be seen on city streets, adding a bit of whimsical magic to the life of urban commuters. Indeed, the large amount of advertising work that Boris and Julie have done at the beginning of the 21st century seems to indicate that the corporate world and society as a whole are becoming increasingly more appreciative of the fantastic.

IMAGINISTIX

Temptress For Inner Wisdom
MEDIUM Oil on Canvas

Temptation (Boris Vallejo & Julie Bell)
MEDIUM Oil on Canvas

ADVERTISING

◀ I Love You So (Boris Vallejo & Julie Bell)
MEDIUM Oil on Canvas

Ninja
MEDIUM Oil on Canvas

IMAGINISTIX

Basketball
MEDIUM Oil on Canvas

Haunted (Boris Vallejo & Julie Bell)
MEDIUM Oil on Canvas

IMAGINISTIX

Power Drink (Boris Vallejo)
MEDIUM Oil on Canvas

ADVERTISING

IMAGINISTIX

Energy Unlimited (Boris Vallejo)
MEDIUM Oil on Canvas

ADVERTISING

IMAGINISTIX

Motocross Riders
MEDIUM Oil on Canvas

Sweet Memories (Boris Vallejo & Julie Bell)
MEDIUM Oil on Canvas

IMAGINISTIX

▲
Jermaine (Boris Vallejo & Julie Bell)
MEDIUM Oil on Canvas

ADVERTISING

The Winners
MEDIUM Oil on Canvas

IMAGINISTIX

Hares vs. Magpies (Boris Vallejo & Julie Bell)
MEDIUM Oil on Canvas

ADVERTISING

IMAGINISTIX

Evil vs. Good (Boris Vallejo & Julie Bell)
MEDIUM Oil on Canvas

Inner Wisdom (Boris Vallejo & Julie Bell)
MEDIUM Oil on Canvas

ADVERTISING

◀ My Love (Boris Vallejo & Julie Bell)
MEDIUM Oil on Canvas

Lucky Goats
MEDIUM Oil on Canvas

93

BOOKS

Despite the adage to never judge a book by its cover, a strong illustration is often cited as one of the most powerful tools for selling a novel, second only to the reputation and previous success of the author. This is particularly the case in the genre of science fiction and fantasy, where painted covers still dominate the scene. To date, Boris and Julie have produced more than 500 book jackets, and it all started with one late-night decision over 30 years ago to throw caution to the wind and take a chance on a new line of work.

Boris's leap from advertising illustration to fantasy covers took place in the early 1970s. Though he had been living in the United States for some years, his sister Patricia was still in Peru and he could not afford to buy her a plane ticket with the salary he was making. Although already working full time as a staff artist doing retail advertising, Boris decided to take on some freelance work in order to raise the money. Through an old friend, he picked up a job doing the interior artwork for a war comic entitled "Fight the Enemy."

As it would turn out, the experience would not be a positive one. After a long day of drawing kitchen appliances and barbecue grills, he would then have to labor over a stack of unfinished comic pages, often working until 3am or later. To top it off, his art director was curt and unenthusiastic, leaving Boris feeling very discouraged. It was shortly after this that Boris discovered the work of Frank Frazetta and Gray Morrow through their covers on *Eerie* and *Creepy*. Feeling unsuited for comic book drawing and frustrated with retail advertising, he decided that cover illustration might be his next step.

Working late one night on a series of refrigerator diagrams, Boris, in a brash and, what would normally be considered ill-advised, act of frustration, abandoned his assignment and painted instead a cover sample featuring a rampaging barbarian. Luck was with him and James Warren (publisher of *Eerie* and *Creepy*, as well as several other titles) purchased the piece. With this, Boris made a decision to devote himself to cover artwork. In the next few years, he went through a series of agents. Unfortunately, as his portfolio consisted almost entirely of advertising work, all they brought him was more advertising work. In the end, Boris decided that he had to strike out on his own. Still following the influence of Frazetta, he took his work to Ace Books which, at that time, was the center of the fantasy paperback market. It was at Ace that Boris finally received his first book jacket assignment, a cover for an Edgar Rice Burroughs novel titled *I Am a Barbarian*.

Painting book covers was an evolved career choice for Boris, whose primary concern up to this point was simply to find a line of work which would pay the bills. The idea that he would move to New York and become a famous freelance artist had not even occurred to him. The idea was equally remote to Julie Bell, who, at about this time, was just graduating high school and trying to figure out what direction her future would lie in.

Julie had always possessed a love for illustration and, at a young age, she saw book covers as the pinnacle of the field. She recalls William Edward's painting for Hermann Hesse's Siddhartha being the first to really capture her imagination. Though eventually she would realize that there is a great variety of illustration work which she enjoys, covers were something that held great appeal to her for many years. In spite of this, her ambition was not initially to paint covers for novels, but to make children's books. Her first experience with this was in the very early 1980s when she provided illustrations for a Nancy Drew parody called *The Mystery of Kawbawgam's Grave*, set in Marquette, Michigan. Though Julie enjoyed drawing and painting, she would only sporadically produce over the next several years. It wasn't until meeting Boris that she truly began to devote herself to becoming a professional artist. She began by doing work for *Heavy Metal* magazine and, shortly after, she was given her first book cover, *Stonehenge: Where Atlantis Died*, from Tor Books. This was followed by a couple of Conan covers, an assignment which she was proud to receive, though it presented a challenge to her as she was not

accustomed to painting masculine and gritty subject mater. In these early years, Julie would experiment in different genres such as westerns and romance novels. She was told, however, that her women were too empowered and so she ultimately settled into the fantasy market, where her portrayals of strong, self-assured women were much more appreciated.

Painting book covers is a process which Boris and Julie both enjoy a great deal. When it comes to creating a cover, the artist has one specific and very important duty: to make the reader pick up the book.. The cover artist is foremost concerned with getting their attention. A great deal of this is done with strong colors and composition. A good cover will grab your eye from across the room, and simplicity can be a terrific tool in focusing your interest.

Once Boris and Julie have caught your eye, however, they still need a solid concept with fascinating details to pull you in. These are generally described by an art director, who will often have a specific scene from the book in mind to be illustrated. Of course, every art director has his or her own method, and some are more precise in their vision than others. Some will begin with a clear idea of the cover from the very start, while others will provide a manuscript and encourage the artist to bring his or her own interpretation. Though Boris and Julie both agree that it's best when they can read the entire manuscript before beginning a painting, it's rare that they have the time and so they are typically just given the basic facts they will need, such as descriptions of characters, a synopsis of the story, and key scenes chosen by the editor or author.

Since the painting will be reprinted at a small size, it's important to begin by visualizing the piece on a miniature scale. Julie always begins with two inch by three inch thumbnail sketches to block in the basic composition. This way, she can be sure that her image will still have a powerful impact even after being greatly reduced in size. Before the painting process begins, she makes an effort to understand the characters which she's painting so that she can better portray their subtleties and give them richer feeling and expression. Both Boris and Julie like to use friends and family as their models because they find that they can get more involved in the personalities and expressions when painting people whom they know well.

Another important aspect to a cover is the story-specific details which must be included. Often, these details will go overlooked or make little sense before the reader has finished the story, but they are always appreciated afterwards. Sometimes, these details will give an illustration new levels of meaning by the time the reader has reached the end of the book. These same details are often the mysterious and enigmatic teasers which might prompt a prospective reader into opening up the book to learn more.

What Boris and Julie enjoy most in painting book jackets is the idea that they're illustrating a whole story with one image. The paintings they create must clearly represent the books they are painted for, much the way a movie trailer might represent a film. The cover will visually describe to you the purpose of the book and prepare you for the type of story which you are about to experience. Throughout the reading, you can refer back to it and compare your own mental images with those shown on the cover, or use the cover to spark your own imagination. When done well, a strong cover illustration can increase your enjoyment of the corresponding story dramatically, and Boris and Julie receive a great deal of satisfaction from a job well done.

IMAGINISTIX

Tek War (Boris Vallejo)
MEDIUM Oil on Canvas

BOOKS

IMAGINISTIX

Tek Secret (Boris Vallejo)
MEDIUM Oil on Canvas

BOOKS

IMAGINISTIX

Rites Of Manhood (Julie Bell)
MEDIUM Oil on Canvas

Julie 2003

BOOKS

◀ Shades Of Vampire (Julie Bell)
MEDIUM Oil on Canvas

▲
Graveyard Spell (Julie Bell)
MEDIUM Oil on Canvas

105

IMAGINISTIX

Godsfire (Boris Vallejo)
MEDIUM Oil on Canvas

BOOKS

Sword And Ivy (Julie Bell)
MEDIUM Oil on Canvas

Blacksmith (Julie Bell)
MEDIUM Oil on Canvas

IMAGINISTIX

JOHN FLINT ROY
24722/$1.75
BALLANTINE BOOKS
SF

A GUIDE TO BARSOOM
THE MARS OF EDGAR RICE BURROUGHS

FULLY ILLUSTRATED

Ready For Battle (Boris Vallejo) ▶
MEDIUM Oil on Canvas

110

BORIS ©79

BOOKS

◀ King's Daughter (Boris Vallejo)
MEDIUM Oil on Canvas

Time Cop (Julie Bell)
MEDIUM Oil on Canvas

113

IMAGINISTIX

Dinner Conversation (Julie Bell)
MEDIUM Oil on Canvas

Vampire Spell (Julie Bell)
MEDIUM Oil on Canvas

◀ In The 42ⁿᵈ Dimension (Julie Bell)
MEDIUM Oil on Canvas

IMAGINISTIX

The Red Menace (Boris Vallejo)
MEDIUM Oil on Canvas

Fire Dance (Boris Vallejo) ▶
MEDIUM Oil on Canvas

Friends Forever (Julie Bell)
MEDIUM Oil on Canvas

IMAGINISTIX

TIMESCAPE

THE FIRST COLLECTION OF ITS KIND FROM A MASTER STORYTELLER AND PULITZER PRIZE-WINNING AUTHOR!
MICHAEL SHAARA
SOLDIER BOY

Ender's Game (Julie Bell) ▶
MEDIUM Oil on Canvas

122

BOOKS

◄ **Mortal Gods** (Boris Vallejo)
MEDIUM Oil on Canvas

IMAGINISTIX

Concept sketch
MEDIUM Pencil on Paper

Ancient Heroes (Julie Bell)
MEDIUM Oil on Canvas

BORIS

BOOKS

◀ The Cat In The Mirror (Boris Vallejo)
MEDIUM Oil on Canvas

Sketch for *Rogue* cover (Boris Vallejo)
MEDIUM Pencil on Paper

129

IMAGINISTIX

Swedish Fairy Tale (Julie Bell)
MEDIUM Oil on Canvas

Jordan Creek (Julie Bell)
MEDIUM Oil on Canvas

The Sun Princess (Boris Vallejo)
MEDIUM Oil on Canvas

IMAGINISTIX

Underground Escape (Julie Bell)
MEDIUM Oil on Canvas

Transfiguration (Boris Vallejo)
MEDIUM Oil on Canvas

◀ Beastmaster (Julie Bell)
MEDIUM Oil on Canvas

Tony's Rocketship (Julie Bell)
MEDIUM Oil on Canvas

BOOKS

IMAGINISTIX

The Offering (Boris Vallejo)
MEDIUM Oil on Canvas

BOOKS

Without Fear (Boris Vallejo)
MEDIUM Oil on Canvas

Berserker Planet (Boris Vallejo)
MEDIUM Oil on Canvas

IMAGINISTIX

A comic book page by Boris
MEDIUM Pen and ink on Bristol board

The Terrible (Boris Vallejo) ▶
MEDIUM Oil on Canvas

142

◀ War Of The Worlds (Julie Bell)
MEDIUM Oil on Canvas

Rat Wins Again (Julie Bell)
MEDIUM Oil on Canvas

IMAGINISTIX

Encounter In The Woods (Boris Vallejo)
MEDIUM Oil on Canvas

BOOKS

◀ Cyborg (Boris Vallejo)
MEDIUM Oil on Canvas

Sketch for *Rogue* cover
MEDIUM Pencil on Paper

149

IMAGINISTIX

BOOKS

Starbridge (Boris Vallejo)
MEDIUM Oil on Canvas

IMAGINISTIX

The Race (Julie Bell)
MEDIUM Oil on Canvas

AND THEN...

Boris and Julie always enjoy meeting a fan. The first sf convention that Boris attended was the 1977 Science Fiction, Fantasy, and Horror Exposition in Tucson, Arizona, and it set the bar pretty high. It was an incredibly extravagant event with a roster of guests including Roger Corman, Mel Blanc, Harlan Ellison, Tex Avery, Frederik Pohl, and many other renowned artists, actors, and writers. This was Boris's initiation into the eccentric world of fandom and it made a lasting impression. He and the other guests were shuttled around in limousines, fed at lavish banquets, and treated like rock stars. He recalls some female fans who collected autographs on their bodies, prompting the legendary comic book artist Jim Steranko to post a sign on his autograph table reading "Jim Steranko will sign anything!" After this weekend of red-carpet treatment, Boris remembers returning home to New York with an inflated ego, only to have his friends and neighbors quickly squash it back into place for him.

Julie's first big public appearance was in 1994 at Baltimore's Diamond Distribution Comic Book Convention, where she was promoting her new trading card set. She was a little nervous, being there without Boris, but she quickly became comfortable after meeting some friendly fans and autograph seekers (including baseball legend Reggie Jackson, a childhood hero) and gave a slide presentation and lecture about her work. Boris and Julie still make it out to a large convention every few years, but these occasions are rare as they are kept home by a constant flow of work and Boris's Hobbit-like tendency to remain in his comfortable home studio.

Today, Boris and Julie maintain daily contact with their fans through their website. The age of instant communication allows them to know exactly what their fans want to see. Julie is especially touched when she receives an email from a female fan who finds her work inspirational. Indeed, many young women have written explaining how Julie inspired them to become artists. Fan mail arrives daily from every populated corner of the globe, often coming from such far-flung regions as Russia, Africa, India, the Middle East, and China.

While most of their art is made with a general mainstream demographic in mind, some things are specifically for the fans, especially where collectable items are concerned. The images Boris and Julie paint are often called upon to transcend the two dimensional realm. If a work of art is something that can be held by human hands, it then touches us on an intimate level, in some ways deeper than a remote picture hanging on a wall or printed in the pages of a book. Evidence of this deep compulsion to possess and collect the small fetish object can be seen throughout the history of mankind, from prehistoric stone and clay figurines, to voice-chip and ray gun-equipped little plastic spacemen.

In the 1990s, The Franklin Mint found great success manufacturing a series of collectable knives, swords, sculptures, pocket watches, and even model cars

featuring the art of Boris and Julie. It was through this medium that a large American audience, which until then may not have been into fantasy and science fiction art, got its first taste. Julie's designs of bikini-clad women riding biomechanical motorcycles turned out to be a huge hit among collectors, and Boris and Julie's dragon knives with flame-shaped blades sold in the millions.

Another form of collectable that exploded in popularity alongside the 1990s comic book boom was the non-sport trading card. There were many appealing factors to these little items: they were small but high quality prints that were relatively inexpensive to collect, and there was an excitement in opening up a pack to discover what was inside. Boris's first series of trading cards was released by Comic Images in 1991 and featured previously published art, mainly from his book covers. It was tremendously successful, paving the way for fantasy and sf related card sets of many other artists. Several more Boris sets followed and in 1994 Julie had a set released by Cardz. Comic Images later put out a couple of "Boris & Julie" sets and a unique set called "Images of Josephine By Boris & Julie" featuring the artists' photographs of model Josephine Maisonet.

In 1996, Fleer/Skybox printed a set of Marvel Comics characters painted by Julie and Boris. The series of 99 paintings took a year for them to complete and the set included nine "Painting Redemption Cards" randomly inserted into packs, which could be exchanged for the original painted artwork. After Magic: The Gathering created a market for collectable card games, Cardz released "Hyborian Gates," a game featuring art from more than 400 paintings by Boris and Julie. The game's rules were obtuse and the art shown on the cards was severely cropped, often cutting semi-nude figures off at the shoulders. It wasn't very successful.

Boris and Julie are, as always, painting every day, all day long. They don't intend on letting their fans down.

IMAGINISTIX

Painting Life On Earth.

Life On Earth (Boris Vallejo & Julie Bell) ▶
MEDIUM Oil on Canvas

AND THEN...

◀ Humans vs. Mutants (Boris Vallejo & Julie Bell)
MEDIUM Oil on Canvas

Mistress Of The Dunes (Boris Vallejo)
MEDIUM Oil on Canvas

IMAGINISTIX

A set of tarot cards is in the works!

The Ultimate Sin (Boris Vallejo) ▶
MEDIUM Oil on Canvas

AND THEN...

The Emperor sketch for the tarot card set.

◀ Mutants vs. Humans (Boris Vallejo & Julie Bell)
MEDIUM Oil on Canvas

165

IMAGINISTIX

Attack Of The Misfits (Boris Vallejo & Julie Bell)
MEDIUM Oil on Canvas

Mutant Warrior (Boris Vallejo & Julie Bell)
MEDIUM Oil on Canvas

AND THEN...

Shadow Hunter (Julie Bell)
MEDIUM Oil on Canvas

Sketch for a computer game
MEDIUM Pencil on Paper

169

IMAGINISTIX

The Power Of Nature (Boris Vallejo)
MEDIUM Oil on Canvas

Human Warrior (Boris Vallejo & Julie Bell)
MEDIUM Oil on Canvas

IMAGINISTIX

Dragon's Dungeon (Boris Vallejo & Julie Bell)
MEDIUM Oil on Canvas

AND THEN...

IMAGINISTIX

Angel Man (Boris Vallejo)
MEDIUM Oil on Canvas

Creativity (Boris Vallejo & Julie Bell)
MEDIUM Oil on Canvas

IMAGINISTIX

Demise (Boris Vallejo)
MEDIUM Oil on Canvas

AND THEN...

IMAGINISTIX

A tankard for The Franklin Mint
MEDIUM Pencil on Paper

Vamp And Zom (Boris Vallejo & Julie Bell)
MEDIUM Oil on Canvas

AND THEN...

◀ Mistress Of The Moon (Boris Vallejo)
MEDIUM Oil on Canvas

Ice Cream King (Julie Bell) ▲
MEDIUM Oil on Canvas

181

IMAGINISTIX

Daydream (Boris Vallejo)
MEDIUM Oil on Canvas

Baltimore Guy (Boris Vallejo & Julie Bell)
MEDIUM Oil on Canvas

◀ Snow Queen (Boris Vallejo)
MEDIUM Oil on Canvas

The Glow Of Victory (Boris Vallejo & Julie Bell)
MEDIUM Oil on Canvas

IMAGINISTIX

The High Priestess

Jennifer (Julie Bell) ▶
MEDIUM Oil on Canvas

AND THEN...

◀ Goddess Of The Waves (Boris Vallejo)
MEDIUM Oil on Canvas

Meat Loaf (Julie Bell)
MEDIUM Oil on Canvas

189

IMAGINISTIX

Never Surrender (Boris Vallejo & Julie Bell)
MEDIUM Oil on Canvas

Come What Will (Boris Vallejo)
MEDIUM Oil on Canvas

IMAGINISTIX

Aqua Teen Hunger Force (Boris Vallejo)
MEDIUM Oil on Canvas